P9-DFS-289

Creative Techniques for
Photographing Children

REVISED EDITION

VIK ORENSTEIN

WRITER'S DIGEST BOOKS
CINCINNATI, OHIO

Photographer/writer Vik Orenstein owns and operates KidCapers Photography (formerly KidShooters) and Tiny Acorn Studios—both nationally recognized photography studios specializing in hand-colored child portraits. She has both consulted as a child photography expert and shot for Nikon and Pentax. Vik makes frequent television appearances to give advice on how to make great pictures of kids.

Creative Techniques for Photographing Children. Revised Edition. Copyright © 2001 by Vik Orenstein. Photographs copyright © 2001 by Vik Orenstein. Manufactured in China. All rights reserved. No part of this book may be reproduced in any form or by any electronic or mechanical means including information storage and retrieval systems without permission in writing from the publisher, except by a reviewer, who may quote brief passages in a review. Published by Writer's Digest Books, an imprint of F&W Publications, Inc., 4700 East Galbraith Road, Cincinnati, Ohio 45236. (800) 289-0963. Revised edition.

06 05 04 03 02 6 5 4 3 2

Library of Congress Cataloging-in-Publication Data

Orenstein, Vik
 Creative techniques for photographing children / Vik Orenstein.
 p. cm.
 Includes index.
 ISBN 1-58297-028-9
 1. Photography of children. I. Title.
TR681.C5 O74 2001
778.9'25—dc21 00-065025

Edited by Brad Crawford
Cover design by Camille Ideis
Interior design by Paul Neff
Interior production by Ben Rucker

COURAGE IS SEEING THE WORLD

for what it is and loving it anyway. This book is dedicated in celebration of Hanna Edgar, a courageous little girl.

I'D LIKE TO THANK THE FOLLOWING PEOPLE FOR THEIR HELP ON THIS BOOK:

Albie Sher, my daughter and inspiration
Oscar Collier, founder, Collier & Associates
Diana Collier, my agent
Judy Davis, friend, cousin and general manager of
 KidCapers Photography and Tiny Acorn Studios, Inc.
Dale Wolf, my faithful and tireless nitpicker

Procolor Lab
 Janet Budzinski
 Kelly Ruchs, digital artist
Black & White, Inc.
 Dinah Biermann, Pres.
 Mike Daoust, V.P.

Image Tech Solutions
 Dale Wecker, rep
West Photo
 Patrick Guddal, rep
Abdo Publishing Co.
 Jill Hansen

THE KIDS WHO APPEAR IN THIS BOOK:

Ariane Ackerberg
Sam Ackerberg
Hannah Lisa Anderson
Ben Barghini
Caroline Berg
Peter Berg
Stuart Berg
Krista Bolles
Lauren Bolles
Lindsay Bolles
Whitney Bolles
Alexa Camarena
Talia Camarena
Marisha
Arianna
Michael Jacob Christensen
Sonja Ann Christensen
Selena Davis
Avery Delahanty
Finn Delahanty
Zachary Dorman-Jones
Brynne Edgar
Nina Ferguson
Wesley Ferguson
Abby Mackenzie Fink
Angelo Fraboni
Dominic Fraboni
Gino Fraboni

Gabbie Fulmer
Logan Fulmer
Lon Garelick
Katie Gerdes
James Gilchrist
Sam Graber
Spencer Graber
Zachary Graber
Omar Een Hajji
Soraya Een Hajji
Ashley Heltne
Jessica Ann Hennes
Justine Nicole Hennes
Robin Jones
Ryan Kellogg
Andrew Lee Kitzenberg
Celine Marie Kitzenberg
David Alan Kitzenberg
Simon Kohnstamm
Sloane Kohnstamm
Lex Kosieradzki
Nick Kosieradzki
Zoe Kosieradzki
Kazuta Kuroki
Mia Kuroki
Blakey Hartnett Larsen
Peter Hartnett Larsen
Amanda Lee

Mercedes Lee
Lillian O'Brien Lelich
Patrick O'Brien Lelich
Rosemary O'Brien Lelich
Beth Masters
Emily Masters
Katherine McDonald
Gerrid McMorrow
Freddie McNeil
Gavie McNeil
Joey Nicpon
Nicole Nicpon
Alexander Buhler Oser
Caroline Elisabeth Owens
Cole Zhores Paiement
Ashley Peck
Breanna Peck
Chelsey Peck
Brian Pueschold
Michael Pueschold
Natalia Pueschold
David Rassmussen
Ashley Ring
Mishawn Ring
Andrea Rutchik
Max Rutchik
Ronni Saxon
Samantha Shaller

Stacey Shaller
Albie Sher
Alison Sipkins
Nicole Sipkins
Crystal Sonifer
Tony Sonifer
Anthony Stanford
Ben Stein
Brooke Stein
Carly Stein
Lauren Stein
Brett Striker
Erin Striker
Matthew Davis Thiel
Travis Jordan Thiel
Chase Turner
Lark Turner
Melley Turner
Mills Turner
Katie Veechi
Tomecia C. Watson
Louise Winslow
Alexandra Wolf
Mia Wolf
Danny Wozniak
Kevin Wozniak

THE ADULTS WHO APPEAR IN THIS BOOK:

Michael Fink
Patti Kelley

Kazunori Kuroki
Ruth Kuroki

Brian Pueschold
Orrie Rutchik

Michelle Shaller
Mike Striker

THE AMATEUR PHOTOGRAPHERS WHOSE WORK APPEARS IN THIS BOOK:

Marnie Jones
Wendy Zueli

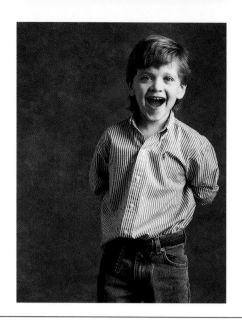
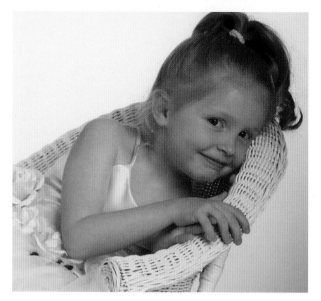

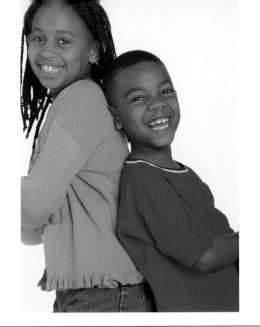
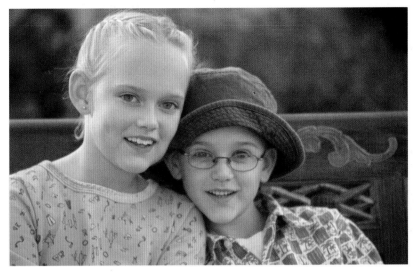

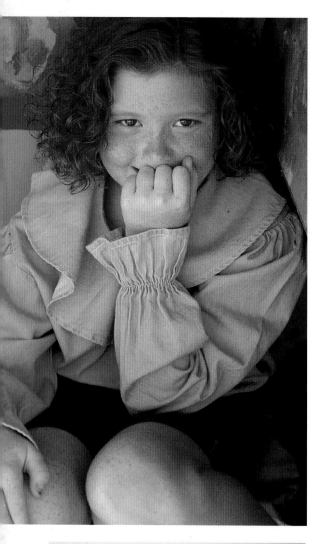

The mom who shot this portrait is a singer and musician by trade, but her artistic bent extends into photography as well.

Photo by Marnie Jones.

There are a million wonderful reasons for making photographs of children. Parents document their children's growth and development and sometimes create portraits worthy of display as decorative objects. Professional photographers create commercial pieces and portraits of children for profit. A fine art photographer creates art pieces featuring children. A photojournalist captures the feeling and spirit of a single family, an entire culture or even a moment in history in the faces of child subjects.

I came by my specialty of child photography quite by accident after working in architectural and commercial areas. I started KidCapers as *revenge* against Grandma. (Sorry, Grandma Esther. I love you just the same.)

Grandma used to take my sister and me to have frequent formal portraits made when we were small. Whether the portrait was a photograph, a charcoal drawing or a silhouette cutting, the process always involved the cruel and unusual punishment of having our hair "fixed" and being forced into dresses with scratchy tulle skirts, twisted tights and pinching shoes, and—horrors!—being made to *sit still*. Then, in the mid seventies, when action shots became de rigueur in fashion magazines, I thought to myself, "Now that's the way kids should be photographed—running, leaping and laughing. And wearing their 'everyday' clothes."

For a full decade I railed to anyone who would listen about the sad state of children's portraiture until I finally decided to be quiet and do something about it. The results have been outstanding. My black-and-white and hand-colored portraits of children tripled the size of the business in the first year, and we're still growing. KidCapers Photography has earned us television appearances and articles and cover photos in national magazines. And in 1994, I opened Tiny Acorn Studios, Inc., specializing in a more affordable, less labor-intensive style of hand-tinted photos. That studio has two locations, with a third scheduled to open in 2001.

More important than the financial rewards or the recognition we've received through KidCapers are the kids we've come to know and love. We've met all kinds of kids: healthy and ill, of many ethnic backgrounds, pampered and poor and many with special needs. I had minimal experience with children when I began KidCapers and didn't know what to expect. Would sick children be sad? Would pampered ones

be spoiled? Would the physically challenged be somehow different from the able-bodied? I've discovered that no matter what adversity kids face or privilege they enjoy, they have a strength of spirit many adults would envy. They all respond with delight to genuine warmth, respect and attention.

Readers of this book will have different reasons for their interest in child photography. But whatever your reasons or level of technical expertise, the fascination with childhood's abundant beauty, grace and wonder unites.

A NOTE TO AMATEUR PHOTOGRAPHERS You may not be a professional, but you have the two things that make for a superb children's photographer. Coincidentally, they are the same two things that make for a superb criminal suspect: opportunity and motive.

You spend lots of time with your kids. They already know and love you; you don't have to earn their trust. You're privy to those real-life moments that make great photos. If you pull out your camera often, tinker with it and shoot casually while your children are engaged in everyday play instead of hauling it out just for birthday and Christmas "lineups" (*Now say cheese*), they will accept your photographic endeavors, and you will be rewarded with success. Happily, you're lacking only two things that the professional photographer has: a studio and an awareness of equipment, materials and techniques.

This picture was taken by a mom who learned how to shoot and print her own beautiful, professional-looking portraits of her daughter in a few photography classes through community education programs.

Photo by Wendy Zeuli.

This book will help you learn the technical and creative skills that will help you take great shots of your kids. Then when those magic moments arise, you won't wonder which lens to use, fumble for the wrong roll of film or keep your fingers crossed that you have the right light. And while it's true that you don't have the control a studio provides, this book will help you use available light and locations like a pro. You'll create candid pictures that are every bit as precious, and perhaps more personal and intimate, than studio shots.

Don't assume that you need thousands of dollars of equipment to take fantastic photos. In my studio, I have at my disposal enough types of artificial light sources to shoot a different lighting look each day for a year. But my favorite way to shoot is to use natural window light and two cardboard reflectors. I have heard it said (in reference to mathematics) that simplicity is elegance. I believe this also is true in photography. The beautiful portraits that illustrate this introduction were shot by parent/amateur photographers.

A Note To Professional Photographers

There is a greater demand now for child photographers than ever before. The popularity of portraits as art and decorative objects, especially black-and-white photos, has resurged. Two-career families with children (and discretionary income) have the sophistication to look beyond photo mills and conventional portrait studios and to demand and recognize the value of unique, beautiful work.

In the commercial world, children are being used in ads selling products totally unrelated to diapers, toys or kids' clothes. Think of the babies featured in ads and television spots of Michelin tires. Stock photo agencies have a greater need for work featuring children as well.

And, of course, there always have been, and always will be, fine art and journalistic photographers focusing their attentions on children. No matter what your area of photographic specialty, you can increase your business by learning to put your knowledge and creative techniques to work with children.

Whether you're a serious amateur photographer preserving moments of your children's lives or a professional photographer shooting kids for commercial, portrait, fine art or journalistic applications, I hope this book will help you in celebrating the beauty and nature of children.

—Vik Orenstein

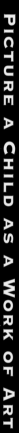
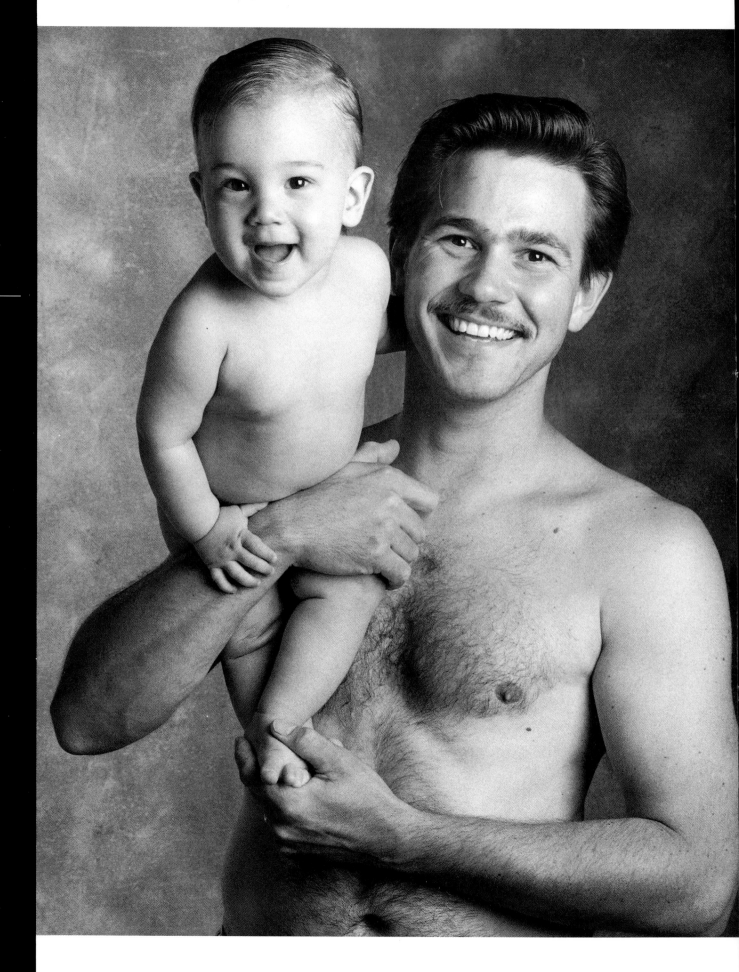

Portraits made in the studio needn't be formal—this studio shot has the spontaneity of a candid.

Strobes; studio; Nikon 8008; Nikkor 35–105mm zoom AF lens; Kodak Plus-X 100 (b&w professional film).

THE PERFECT SUBJECT

An artist of any medium can choose no better subject than a child. Endlessly energetic, constantly changing, guileless, naturally beautiful—children make eternally intriguing, charming, exciting subjects. By portraying a child, you break open in the viewer a stronghold of feelings, memories and experiences, for we all have been children. An artfully and thoughtfully executed photograph of a child can awaken in the viewer feelings of security and vulnerability, joy and grief, playfulness and solemnity, all of an intensity that we may have long forgotten we're capable of. Children in and of themselves are works of art.

THE PHOTOGRAPHIC ATTITUDE

When I talk about my work as a photographer, I always say that I make pictures, not take pictures. A painter doesn't "take" a painting, and a sculptor doesn't "take" a sculpture. "Taking a picture" implies that the image is out there waiting to be picked, like a flower. In fact, when a photographer points a camera at a subject, she is not simply recording the image, she is interpreting it, and the tens of choices she makes—film type, f-stop, exposure, lens, format, manipulation of light, perspective, interaction with the subject, framing, to name just a few—make the finished picture uniquely her own. If you think you are merely "taking a picture," you may be seriously limiting yourself. While there is only one way to take a picture, there are millions of ways to *make* a picture.

The best photographers use their art to interpret and comment on our world. Photography is not simply a tool of documentation. While it *might* be possible to record an image photographically that seems to look exactly as the subject appeared to the naked eye at the moment it was made—an image, in other words, that seems real—the best photographs are not so literal; they are enhanced through the eyes of the photographer to evoke moods and emotions.

Think about how we as human beings see an image. Only once do we see a moment as it actually happened. Then we see it again many times as we replay it in our memories, colored by our personal experiences, biases and the passage of time. Who is to say that the way the images appear to us in memory are inferior to "the real thing"?

Kids make great subjects even when they are showing off.

Strobes; studio; Nikon 8008; Nikkor 35–105mm zoom AF lens;
Fuji Velvia 50 (professional film).

When I make pictures, I try to make them feel the way memories feel—soft, impressionistic and full of emotional significance.

I love to engage in heated discussions with other photographers about what types of film are best for photographing people, and kids in particular. A good friend of mine champions Ektachrome because, he says, "It produces skin tones that look more real." My response to him is: "I don't want my pictures to look real. I want them to *feel* real."

Once you've realized that making pictures is an art, a new realm of artistic and interpretive freedom opens up. And what subject befits an artist better than a child?

ARTISTIC FREEDOM

Of course, the ultimate use of the photograph will affect the amount of artistic freedom you exercise. If you're shooting for your own use and enjoyment, the sky's the limit. But if you're shooting for a client (portrait, commercial, stock or gallery), you may have more restrictions.

Ask yourself before you shoot, "Why am I making this picture? For the family photo album? To create a portrait to hang on my wall? To sell a product? To sell as an art piece? To record a moment of history?"

Regardless of the intended use, all great photographs of kids stand on their own outside of any contest: They all begin as *art portraits*.

WHAT IS AN ART PORTRAIT?

To begin to define what an art portrait is, let's look at the two words: art and portrait. According to *Webster's New Collegiate Dictionary*:

> **Art:** *The conscious use of skill and creative imagination especially in the production of aesthetic objects.*

> **Portrait:** *A pictorial representation of a person usually showing the face.*

Combining these definitions gives us, roughly, "a pictorial representation of a person made with the conscious use of skill and creative imagination." To this I add several criteria of my own. To be successful as an art portrait, the work should also:

• **Be decorative.** Most direct color, formal portraits do not stand on their own as decorative objects. People tend to purchase these in 5 x 7 and 8 x 10 prints to set on a shelf or hang on "the photo wall" in a hallway, to be replaced by the next year's photo. In contrast, an art portrait can be displayed any place one would normally hand other "art," frequently in places of high visibility: over mantels, in entries

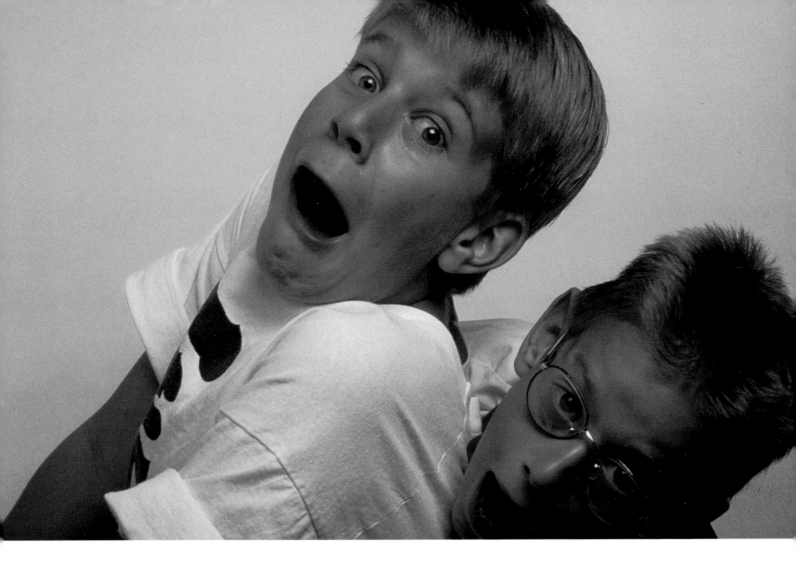

and great rooms. The work remains even when updated portraits are added to the home as the child matures.

• **Show your creative intent.** If you make a photograph with the intent to surpass mere documentation and create artwork that expresses your subject's true essence, you will probably succeed. Conversely, if you make the photo intending only to create a functional representation of your subject (or in the case of a professional photographer, a product for which your client will pay a lot of money), you may fail in achieving either an artistic statement or marketable portrait.

• **Incorporate skill and emotion.** While a work must be well crafted to succeed, skill alone is not enough to satisfy the definition of art. In addition to being skillfully executed, the work should evoke some emotion in the viewer.

• **Capture the essence of your subject.** An art portrait should, as I mentioned before, go beyond simple documentation of the subject's physical appearance. *Personality*—those traits, habits and expressions that make each of us unique—should be evoked, and the social facade should be penetrated. (Yes, even babies have a social facade.) While this quality of personality may seem intangible, I think we all have an instinctive awareness of what gestures and expressions are genuine. I present clients with proof sheets on which I've marked the shots I personally find most successful, and I'm frequently rewarded with comments such as, "Oh, yes,

**Technique can help you capture the spirit of a child. Here I
used a hard side light to emphasize the theatrical feeling
of the boy's gestures and displayed three shots together to
show his fantastic range of expression.**

Strobes; studio; Nikon 8008; Nikkor 35–105mm AF lens;
Kodak Plus-X 100 (b&w professional film).

that's *really* him!" or "Yes, you've captured his *natural* look." Successful portraits
needn't be all smiles and may represent many different moods.

• **Complement your subject.** Your use of applied or direct (i.e., natural) color,
technique, setting, props and other photographic elements ideally will enhance
your representation of your subjects rather than diminish or compete with it.

**PHOTOGRAPHIC
GENRES**

Now, if you approach every picture you make of a child as an art portrait, you will
find that it can cross over into several, if not all, of the common photographic genres.

- Candids refer to any shots that are taken of kids in their own environment,
 busy at play, not performing for the camera. Some people also call candids
 "informal portraits." Candids may be made by amateurs or professionals.
- Studio portraits are made by professional photographers in the controlled stu-
 dio environment, usually commissioned by the children's parents for their
 personal use.
- Environmental portraits are made by professional photographers outside of
 the studio. Popular locations for environmental portraits are wooded areas or
 the child's own home or yard.
- Commercial photographs are made by photographers who specialize in
 advertising work.

- Stock photos are made by professional photographers and photojournalists but are sold by stock agencies to commercial and industrial clients for innumerable uses. The same photo can be resold to may different clients worldwide. These photos are sometimes made for the express purpose of being sold as stock; other times they are photos that were originally made for personal, commercial or journalistic purposes. Pictures of children are in good demand by stock agencies.
- Journalistic photos tell stories about kids in our world today. The photojournalists who make them work freelance, on self-assignment, frequently with the aid of grants, and on assignment for newspapers and magazines.
- Decorative art photographs are created by professional photographers and published by poster companies for hanging in residences and offices. A good percentage of decorative art features children, especially black-and-white and hand-colored photos.
- Fine art photography, including some work featuring children, is enjoying new popularity. Limited editions of black-and-white prints and even direct-color photos made by professional photographers are sold by art and frame galleries.

I focus most of my work on black-and-white and hand-colored techniques because these give me almost total artistic control. I try to portray not miniature adults, but natural kids just being themselves.

Strobes; studio; Nikon FE2; Nikkor 35–105mm zoom AF lens; Kodak Plus-X 100 (b&w professional film).

At least two people are captured in every photo: the subject and the photographer. No matter how anonymous photographers try to be, their personal styles appear in every photo. Each of us has a personal style that comprises the following elements:

- Special vision: our way of seeing, colored by experiences, philosophy and attitudes.
- Feelings about ourselves, children, ourselves as children, the universal experience of childhood and our own personal childhoods.
- Reasons for making pictures of children: to convey a message, for display as an art piece, for our personal use or as a way of celebrating childhood.
- The audience for whom we make the picture: the subject, a commercial client, the subject's parent(s), a stock agency or simply for ourselves.
- Strengths and weaknesses: Whether personal, technical or artistic, these are elements of personal style.
- Knowledge of techniques that allow us to creatively use tools and materials (such as lighting, film types and props) to create images.

Do you need good technique to express your vision, or do you need a vision before you can explore and apply various techniques and materials? To facilitate either preference, this book is divided into three sections that you can read in any order. Whether you develop your technique or your style first is your decision.

Developing your style is like bodybuilding: You already have muscles, but you want to make them bigger or more defined. You already have a personal style, but you want to make it bolder, more distinct. Just as there are muscle-building exercises, so are there style-building exercises.

HOW TO DEVELOP YOUR STYLE

1. **Follow your bliss.** Shoot kids the way you love to see them. Do you like the grace and energy of childhood? Make action pictures of kids running, jumping and dancing. Do you want to show the tender, vulnerable side of children? Shoot candids of kids in pensive moods.
2. **Personalize your photographs.** Interpret, don't just record, your subjects. Communicate your feelings about your subjects and the pictures themselves.

3. **Enjoy the process.** We all enjoy having made a beautiful picture. But we should also enjoy the process. Everything from the concept (who, what, where, why and how to make a picture) to the actual execution (interacting with the child, metering the light, even clicking the shutter) should excite you. If it does, it will come across in your work and enhance your style.

4. **Let wrong be right.** Rather than searching for the "correct" exposure, the "correct" film type or the "correct" lens, you can explore doing things "incorrectly." Perhaps overexposing a certain image will make it beautifully ethereal; underexposing another may give it a rich, moody quality; using a wide-angle lens might transmit a feeling of isolation or expansiveness; shooting in tungsten light with daylight film may create a warm feeling. Many contemporary photographers have forged wildly successful careers by making pictures "the wrong way." Chip Simmons, a commercial photographer, is best known for his pictures made with a fish-eye lens and colored gels. Out of focus, mixed light sources, chrome film processed with negative film chemistry and negative film processed with chrome chemistry—these are just the start of many "wrong" possibilities.

5. **Experiment.** Give yourself hands-on experience with every possible technique, piece of equipment and material you can find. If you like the results, great. If you don't, throw the shots out. You can't possibly know what a given film type, technique or process can do until you try it. When you come across a medium that helps you express your vision, refine it, master it, make it your own.

6. **Welcome failure.** You can't be innovative and try new techniques without failing once in a while. And it really is true that you learn more from your failures than you do from your successes. From my own experience, I know that if I had only attempted photographic techniques that were guaranteed to succeed, I would never have shot a single frame.

 Be willing to fail, but be sure to leave yourself a safety net if you shoot professionally. When you try out a new technique or medium, use your own kids or friends of the family before offering it to clients. Present your experimentation to your subjects and their parents as a "photo test." Explain to them that you're trying out a new idea and if the results are good, you'll give them a complimentary print. That way no one will be overly surprised or disappointed if your attempts fall short.

7. **Let your style evolve.** While it's important to be aware of the message in your pictures and to realize that personal style is shaping the outcome of your

shooting, it's also important not to overanalyze your approach. Indulge your interests. Don't allow your style to remain static—the most successful photographers' styles evolve constantly. Just as the caterpillar forgot how to walk when asked which leg went first, so too can you lose your momentum temporarily if you think too much about what you're doing.

Especially if you're new at photography or new in the area of children's photography, you might not yet be fully expressing your personal style. Rest assured it will emerge through experience.

How my style evolved. As I mentioned in the introduction, my personal style of photographing children springs in part from my averse reaction to the way photos of me in my childhood were made. I was motivated to make pictures of kids as both a means of celebrating children and of self-expression.

I decided to make portraits, in particular, because I think the photo mill and traditional methods of portraiture not only fail to portray their subjects, but are also artless and nonarchival. So I made it my personal quest to make pictures of kids that portrayed their spirit and personalities, that would be worthy of display as art and decorative pieces, and would be archivally preserved, so they could be enjoyed by my subjects' children in decades to come. This vision, these feelings, these reasons and this message all were the basis from which my style began to emerge.

From there I experimented with the different photographic mediums and quickly settled on black-and-white and hand-colored pictures. I found that these mediums helped me meet several of my goals: black and white and applied color are classic, timeless techniques that, when executed with archival materials, will last indefinitely. Since I did my own black-and-white printing, these mediums gave me almost total artistic control over every detail of the final pictures.

I set out to portray my impression of kids—real, moving, casually dressed, with runs in their stockings, crooked neckties, falling straps and messy hair—not the formally dressed and posed, perfectly still "miniature adults" in conventional portraits. My fascination with movement and the informal approach led me to concentrate on full-length rather than head shots.

Not happy relying on one shot to show a kid's entire range of expression, I presented my work in a series of three to nine shots so that many moods, from pout to whimsy, could all work together to tell a story about the child.

Finally, my ultimate expression of movement came in my current specialty, what I call isolation collages. Avant-garde cropping and image juxtaposition exaggerate the child's movement to create a highly energized piece.

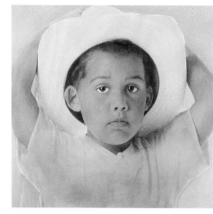

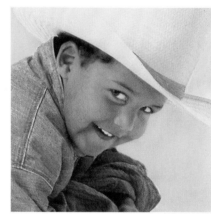

Part of my style involves presenting three or more shots together to portray a range of expressions and movement. I call this an isolation collage—my own expression of a child's energy and movement.

Strobes; studio; Nikon FE2; Nikkor 35–105mm zoom AF lens; Kodak Plus-X (b&w professional film); printed on Agfa Portriga 118 matte paper; colored with Marshall photo oils and pencils and artist's oils.

There is nothing new under the sun.

The art of photography has been around for a bazillion years. Every medium you can possibly conceive has been used by countless others before you. By the time new spins on old materials trickle down to the photography magazines, they've often been done to death by pros on both coasts. Given the limitations of the materials and mediums, the anatomical sameness of human subjects (one head, two eyes, two ears, a nose, a mouth), some might despair of ever making an original or creative picture.

Originality is the *personalized approach* that makes a creative picture. The simplest, most straightforward techniques and materials can create highly creative works when the photographer applies her unique way of seeing and puts herself into her pictures without holding back. And being unrestrained means taking risks. By nature, creativity itself is not risk-free. So to make an original, creative work means going into uncharted territory. Without the potential for failure, there is no originality.

WHAT MAKES A PICTURE CREATIVE?

Sometimes to be creative, you have to make it up as you go. This can give you what some call the impostor syndrome—the fear that you'll be exposed as somehow not good enough or not knowing enough. You must value your talents and trust your ability.

Creativity is capitalizing on your mistakes. As the old saying goes, "A good photographer isn't someone who never makes mistakes. A good photographer is someone who can repeat his mistakes." Mistakes, or accidents, can become the basis for exciting and original new techniques. In the pursuit of originality, it's important to be undaunted by "being wrong."

Creativity uses both intuition and intent. Intuition: subconscious insight and understanding; and intent: conscious judgment and technical expertise working together to create successful photographs. Intuition gives pictures impact, while intent gives you the means to express your intuition.

This portrait, made in our studio for the subject's parents, could also cross over into other genres such as decorative art, commercial and stock photography.

Strobes; studio; Nikon 8008; Nikkor 180/2.8 AF lens; Fuji Velvia 50.

WHAT KEEPS A PICTURE FROM BEING CREATIVE?

Novelty in the use of materials or unusual cropping and style don't make a picture creative, and perhaps more important, they don't make a picture good. Photographs that are avant-garde or different for the sake of being different may yield results that are self-conscious, overly precious or just simply weird. Secret formulas for processing, printing and lighting, and being the first one to use them, won't make your work creative.

Perfection doesn't equal originality, nor does it guarantee a great photograph. In fact, I'm not certain a perfect photograph even exists. Far worse, the quest for perfection can cause paralyzing fear, which I'm convinced has prevented uncountable original pictures from being made.

Working alone doesn't ensure creativity. Having a collaborator—a commercial client, an art director, a photographic stylist or a portrait client—doesn't mean your input or the ultimate product will be any less original or successful than a work you create alone. In fact, my collaborations with commercial and portrait clients have resulted in some surprisingly original work. And many pictures that were created for commercial clients to sell a product actually stand on their own as great photographs.

Complaining about limitations won't make your pictures more creative, either. Imposed limitations, even ones that seem trivial and unreasonable (*Match this portrait to the colors in my sofa, please*), can sometimes result in highly original work. Think of other areas of art in which we embrace artificial limitations: if Shakespeare hadn't written within the strict form of iambic pentameter, we wouldn't have his sonnets.

BORROWING IDEAS AND TECHNIQUES

As a photographer (seasoned professional or amateur) you can learn many new ideas and techniques to add to your creative repertoire from your peers. But where is the line between inspiration and imitation? When do we evolve from borrowing to stealing or even copyright infringement of another photographer's work?

Use the work of other photographers, visual artists and even musicians and writers as a jumping-off place to create your own original work. Dissect the work; determine what elements make it successful in your estimation and what elements are incidental to its success. Then elaborate on the spirit of the work, the medium or the technique, but not the work in its entirety, unless you're using it purely as a learning exercise. Never sell a literal re-creation of another's work to a client. And never try to pass off another's technique or invention as your own. Always acknowledge the sources of your inspiration, and you'll be less likely to be accused of imitation.

On the other hand, whether you share your own discoveries and techniques is up to you. In my experience, photographers who are confident in their abilities are most generous with their knowledge. Of course, when you share your techniques, there is always the chance that someone will attempt a direct rip-off of your methods and may even try to compete with you for clients in your own market. But technique alone doesn't make your work original and creative—it's also your personal vision, which is inimitable.

Composing head shots vertically focuses attention fully on the subject.

Available light; studio; Nikon 8008; Nikkor 180/2.8 zoom AF lens; 3M Scotch 1000 (chrome film).

Composition is the element of photography that seems to me to be the least considered. Many photographers seem to think a good composition is framing the child in the center of the shot without cutting off the head. But a good portrait—one that is well composed—includes not just framing but perspective, field and color. All of these elements should work together to create movement: a great composition makes the viewer's eye flow across the picture.

We tend to make horrible assumptions about composition. Amateur photographers assume that every subject is best shot horizontally; it rarely occurs to anyone to turn their camera sideways for a vertical shot; many assume that the subject belongs in the center of the frame; traditional portrait photographers are especially guilty of assuming that there should be lots and lots of empty space around the subject.

Shake your head and get rid of all those old assumptions. Here are some general rules for composition. But remember, rules are made to be broken!

1. **Switch off your horizontal hold button.**

Ninety percent of the time when you're shooting a human subject, your best format will be vertical. This holds true whether you're shooting full-body, midrange or head shots. Full-length shots have obvious strong vertical lines. The vertical lines of a head shot are less obvious, but looking at the photo of the boy (opposite), note that the line from the top of a human head to the collar bone is about three times as long as the line at the widest horizontal point running from ear to ear. You can even frame the child diagonally to emphasize line and movement.

2. **You don't have to limit subject placement to the center of the picture.**

In a formally balanced, traditional portrait, the appropriate treatment has the subject centered in the frame. However, formal balance is not as simple or as limiting as it sounds. There are many ways to frame (position your subject within the picture). For head shots, you can center the eyes or the head. With multiple subjects, you can center one subject or both. For three-quarter and full-body shots, you can center the subject's eyes, head or body. Again, as for multiple subjects in head shots, you can center just one or all of the subjects.

SIX RULES FOR
GOOD FRAMING

You can add visual interest with diagonal framing. In the first shot, it gives this baby a feeling of flying. In the second shot, the slight diagonal framing emphasizes the tension created by kids balancing on the railroad track.

Near Right: Sunlight; outdoors; Nikon 8008; Nikkor 180/2.8 AF lens; Kodachrome 200 (professional film).

Far Right: Sunlight; outdoors; Nikon 8008; Nikkor 180/2.8 AF lens; Fuji Velvia 50.

Some compositions can be made more exciting if the subject is framed off-center (informal balance), which can create drama and tension. For example, if your subject is looking off out of the frame, you can place her off center to create a space for her to look into. And if several different shots are juxtaposed in a series or collage, they may benefit from being composed with an eye toward informal balance to create or emphasize movement from picture to picture. These are just two choices of many. Let each subject's pose and the setting dictate whether you employ formal or informal balance in your composition.

3. **Fill up the frame with the kid.**

For most, the first impulse is to show too much of the subject's surroundings by shooting too wide. You don't need much background or foreground to evoke the mood of the setting. What you imply is as important as what you actually show. Notice how in the illustration on page 29, you know immediately that this boy is sitting on a fire truck, even though very little of the truck is actually in the frame.

You don't have to have a lot of space around the child—in fact, you don't even have to show the whole child. Head shots can be very successful with no space above the head and even with part of the top of the head cropped off. Full-length

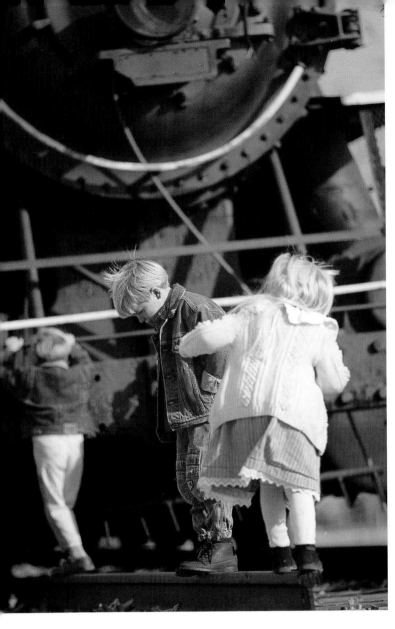

shots generally need a little space above and below the subject, but think before you shoot. Do you really need the whole figure from head to toe, or would this be a better composition if it were shot tighter—say, head to midthigh, or even tighter?

One exception to the rule of filling the frame with the kid is if an object in the field becomes a compositional element that complements or balances the subject, such as in the illustration on page 30. In this case, you must frame the shot wider to include the object.

4. **The eyes have it.**

Generally—but not always—it's most desirable for the person viewing the photograph to be first drawn to the face and especially to the eyes of the subject, because eyes are far and away our most expressive feature. This can be accomplished effectively in simple and complex compositions by employing formal and informal balance.

5. **Maintain only one center of interest.**

Even when there is more than one subject—though the composition becomes more complex—you should still only have one center of interest. Generally, to maintain the flow of your composition, the subjects should be touching one another or overlapping in some way. When photographing multiple subjects in head

I could have framed this shot with the boy's head or eyes centered; I centered his eyes because is emphasizes them more.

Tungsten theatrical lights; studio; Nikon 8008; Nikkor 180/2.8
AF lens; Fujichrome 400 (professional film).

shots, the heads should be close together and the bodies overlapping, as well. It's not always natural for people to position themselves so close together, but some ways to solve this problem are discussed in more depth in chapter thirteen.

6. Make shapes within your composition.

Once I brought a five-year-old French girl into the darkroom with me to show her how a print was made. I was working on an isolation collage that involved a lot of avant-garde cropping. "What are you doing? Why do you make only parts of the picture?" she asked. I was struggling to figure out how to explain composition to her in words that would overcome our barrier when suddenly she said," Oh, I see, you are making shapes!" Voilà!

Here are some simple guidelines for making shapes of people in picture:

- Keep the eyes of the subject in the upper third of the frame.
- Don't crop off limbs at the joints or the person will look like an amputee.
- To balance a shot that is cropped tightly below the subject, crop it tightly from the top, and vice versa.
- If you shoot a child full-body, leave more space above the head than below the feet to avoid the feeling that your subject is floating or that her head is crowded.

These rules may seem like a lot to remember in the heat of photographing an active subject, but after a while it will become second nature, and you will automatically compose your photos.

Field is the foreground, middle ground and background of a photograph. If you pretend that the picture is three-dimensional and turn it sideways, you can imagine these spatial areas. By visualizing your subject's surroundings in three dimensions you can more effectively create compositions that draw the eye to your center of interest—the child. Here are some rules for using field in your compositions:

1. Use objects in the foreground.

Putting objects in the foreground can frame the shot, add depth and visual interest and lead the viewer's eye to the subject. This is a trick of the trade for architectural photographers, who have been known to carry their own tree branches to dangle in front to the camera, just in case the flora around their subject doesn't suffice. On location, it's relatively easy to find objects that lend themselves naturally to use in the foreground: toys, foliage, curtains, architectural elements and even other people. But in the studio, take special care that anything you put in the foreground doesn't look too contrived.

In the first shot, the girl is framed off-center, and her brother is centered; in the second shot, both subjects are centered.

Strobes; studio; Nikon N90s; Nikkor 38–135mm zoom AF lens; Kodak E100SW.

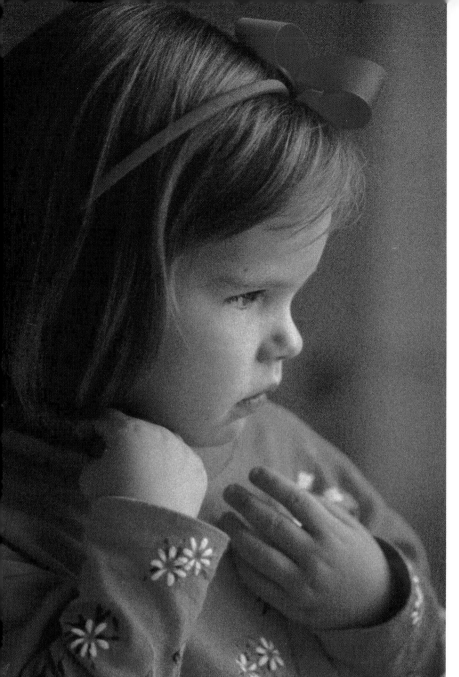

When your subject is looking out of the frame, give her some space to look into.

Available light; studio; Nikon 8008; Nikkor 180/2.8 AF lens; 3M Scotch (chrome film), push processed 1 stop.

2. **Have only one center of interest in the middle ground.**

The middle ground is where your subject is. Objects on the same plane as your subject are also in the middle ground. Since these objects pull attention away from the child, select them with care. If possible, position them in such a way that they are in contact with the subject and are thus a part of the center of interest of the photograph.

3. **Keep the background simple and uncluttered.**

Focus attention on the child. If I shoot on location and the surroundings are a key part of the picture, the trick is to lift the subject off the background by de-emphasizing, not eliminating, it. You can do this by shooting with a shallow depth of field, which means that the subject remains in focus as well as anything on the same plane (the middle ground), while anything in front of or behind the subject (the foreground and background) is slightly out of focus. Shallow depth of field is achieved by shooting at a wide open f-stop with most lenses or by shooting with a

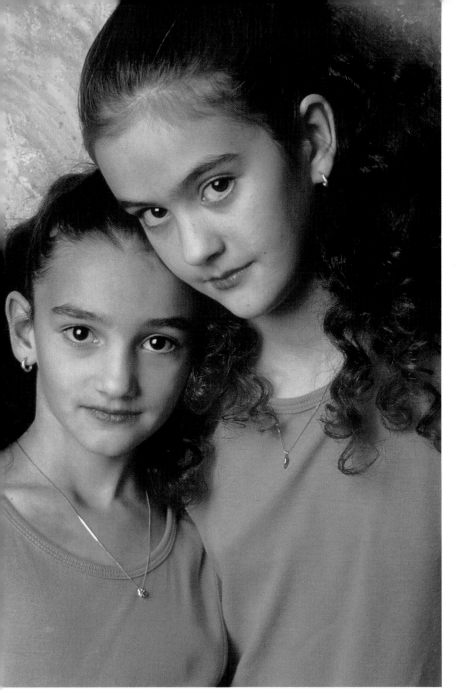

Fill up the frame with the kid(s)! You don't need a lot of background or empty space.

Strobe; studio; Nikon 8008; Nikkor 180/2.8 AF lens; Tiffen #1 soft focus filter, Fuji Velvia 50.

long (135 to 180mm) lens. (More on lenses in chapter eight.)

4. **Position the horizon line above or below the middle of the shot and the center of interest.**

If the horizon line is exactly centered or, for instance, it bisects the subject's eyes, it will distract and lead the eye out of the photo instead of into it.

Some people photograph from their own eye level all the time. This is a big mistake because the perspective you choose can greatly influence the mood and, hence, the entire message of the picture. This is never more true than when the subject is a child. The perspective of a photograph sends us messages both consciously and subconsciously and shapes our feelings about the subject. Shooting from different perspectives can also help a photographer manipulate his field to the best advantage.

FIVE RULES OF PERSPECTIVE

Implication is as important as actuality in your pictures. In
this portrait the whole fire truck is implied by just the
small area you see around the boy.

Open shade; outdoors; Nikon 8008; Nikkor 180/2.8 AF lens;
Fuji Reala 100 (professional film).

1. Shoot looking down at the child to enhance an air of innocence or vulnerability.

Shooting down foreshortens your subject, making the child seem even smaller than he really is. It also shows more of the top of the head, making it necessary in head shots to crop more off the crown to make the child's eyes appear in the upper third of the frame.

2. Shoot at the child's level to see eye to eye.

Being on the same level lets the viewer identify with the child—literally seeing things "on his level."

3. Shoot looking up at the child to emphasize accomplishment.

Putting the child up on a higher level than the camera lends him an air of pride and competence.

4. Use perspective to manipulate your field.

Perspective can isolate the child against different fields. For instance, by shooting up at a child, you can photograph him against a blue sky, setting off an idyllic moment of play. By shooting straight on you can eliminate a cluttered background, which might show from another perspective. By shooting down at the child you can include objects in the foreground that wouldn't otherwise show.

5. Use perspective to manipulate available light.

For instance, if you're shooting on a bright day with the sun high in the sky, you can eliminate long shadows on the face by positioning yourself above the subject and having him tilt his face up at you. Study how different perspectives cause the light to play off the child in various ways.

USING COLOR IN YOUR COMPOSITIONS

Color, or in the case of black-and-white photography, tonal value, is the final element of composition that you can use to manipulate the eyes of the viewer.

1. Use contrasting colors between the subject and the field to lift the child off the background.

A child in a red coat against a stand of evergreens almost seems to pop out of the picture. But a child photographed in a green coat against green trees might fade into the background.

2. Repeat spots of color for a unifying effect.

Using the same color family or tone in the main compositional elements creates a bold visual impact. For instance, a branch with pink flowers in the foreground, framing a child in a pink hat, can lead the eyes of the viewer to the child's face—the picture's center of interest.

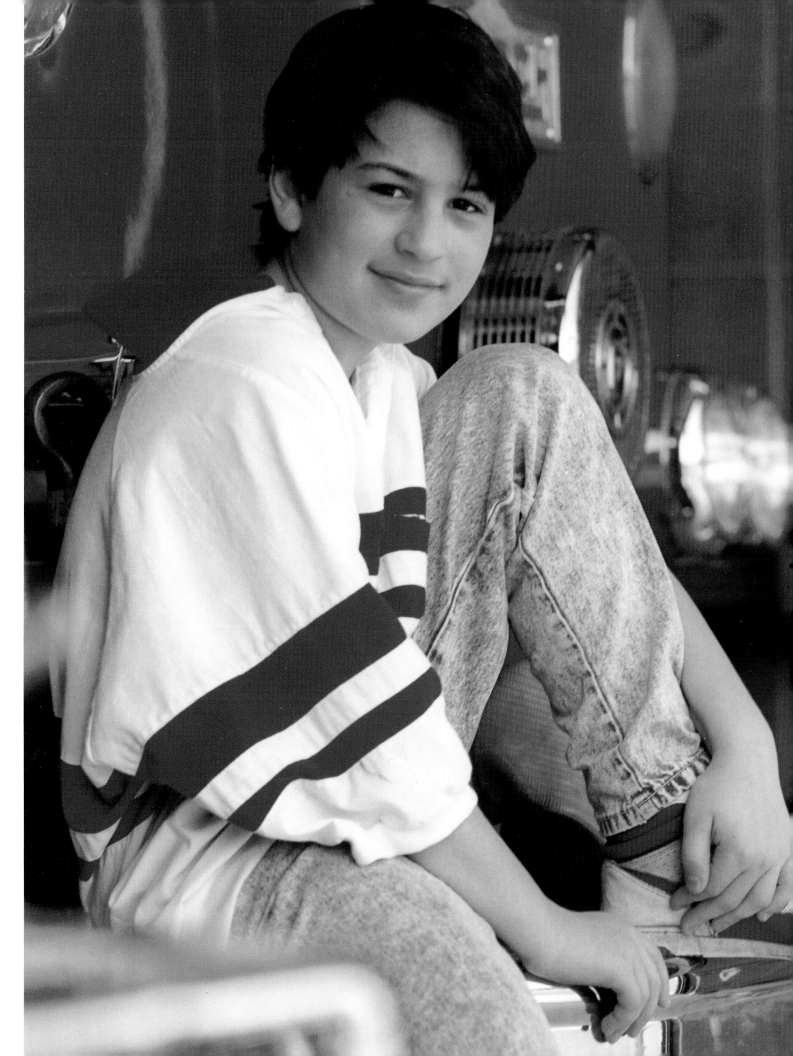

(Left) This shot includes warm compositional elements that draw the eye toward the subject. The pink flowers in the foreground lead your eyes to the girl's pink hat, pink outfit and, finally, to her face.

Sunlight; outdoors; Nikon N90s, Nikkor 38–135mm AF lens; Kodak E100SW

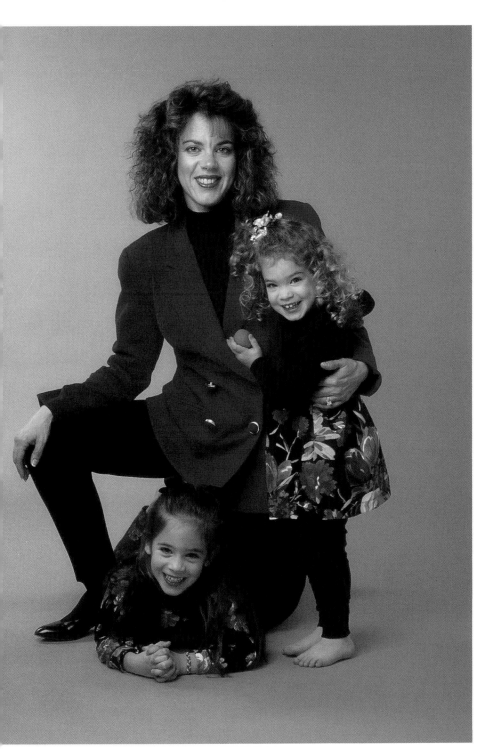

Multiple subjects should touch to create only one area of interest.

Strobes; studio; Nikon 8008; Nikkor 35–105mm zoom AF lens; Fuji Velvia 50.

This little girl's doll collection creates a foreground that frames her and draws the eyes in toward her face.

Available light; indoors; Nikon 8008; Nikkor 180/2.8 AF lens; Fuji Velvia 50.

Informal balance can liven up overall composition when several different shots are juxtaposed. The nontraditional cropping of this collage creates a feeling of energy and motion. If every shot were vertical and centered, the visual impact would have been considerably lessened.

Available light; studio; Nikon N90s; Nikkor 38–135mm zoom lens; Kodak E100SW (professional film).

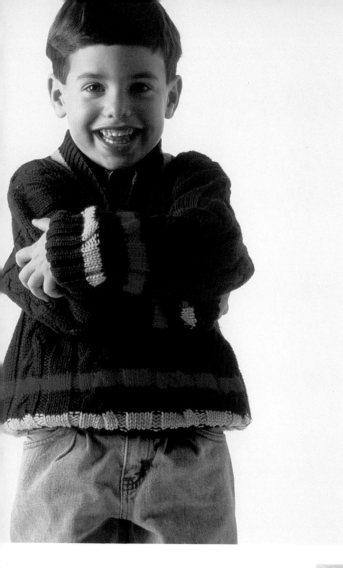

(Right) Shooting down at a child can emphasize a mood of innocence or isolation and the child's small size.

Natural light; studio, Hasselblad 2.4 camera; 80mm lens; Kodak 200 print film.

(Left) Shooting from the same height, or perspective, as these kids puts us on their level and helps us identify with them.

Strobes; studio; Nikon 8008; Nikkor 35–105 zoom AF lens; Fuji Velvia 50.

This girl was shot for an annual report for Big Brothers and Big Sisters of America. We shot up at her to emphasize the fact that she is an athlete and academic achiever.

Strobes; studio; Nikon 8008; Nikkor 180/2.8 AF lens; Kodak Plus-X (professional film); printed on Agfa Portriga 118 matte paper and hand-colored with Marshall photo oils and pencils.

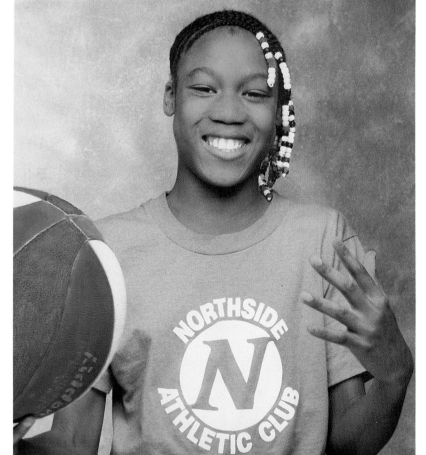

My favorite setup for shooting at home: The subject faces the window with white fill cards on either side of her, and a sheet of pink paper creates an innocuous background.

Available light; indoors; Nikon 8008; Nikkor 180/2.8 AF lens; Kodak Ektachrome 100 (professional film).

An age-old battle is being waged among photographers who champion one type of portraiture lighting over another. Any light is appropriate for children's portraits: hard or soft, natural or studio, and each has its joys and tribulations. The type of light you choose for a given portrait will in great part depend on the feeling you want to evoke. Light, perhaps more than any other single element of a picture, dictates its mood.

To use light effectively, learn to really *see* it. Start paying attention to the way sunlight looks at different times of the day and at different times of the year. How does light look reflected off the water or filtered through tree branches? How does the light from a north-facing window compare to the light from a south-facing window? Understanding the difference between hard and soft light will help you plan your portrait lighting, whether you're shooting outdoors, indoors or in the studio: *hard light* comes from a small, direct light source; *soft light* comes from a large, diffused or indirect light source.

SHOOTING IN NATURAL LIGHT

Pros
- Natural outdoor light, used by a skilled photographer, can make unbelievably beautiful pictures. While natural light can be imitated in the studio, its subtlety is rarely equaled.
- What you see is approximately what you get; there's no need to guess or shoot Polaroids to predict your results.
- It's free, and you don't need to haul any heavy equipment.

Cons
- You have to take what you get—natural light dictates where and when you shoot.
- It can change in a split second; even a small, puffy cloud passing over the sun could change your exposure by one, two or more stops.
- You run the risk of having to reschedule because of bad weather. The parent of your subject should understand that a shoot in natural light is "weather permitting."

- You are always limited to certain times of day and certain ways to orient your subject. The options for when to shoot become more limited during fall and winter as the days grow shorter.

For best results

- While logic calls for posing your subject looking into the sun, this makes for a squinty-eyed, uncomfortable kid: orient your subject with his back to the sun and use a strobe to light his face, orient the sun to one side of the child; or shoot in open shade.

- Shoot at times of the day—and the year—when the sun is low in the sky to avoid dark eye sockets and long shadows under noses. Early morning, late afternoon and early evening during spring and fall are great times because of the sunlight's warm tone and gentle angle. Avoid shooting in the bright, harsh light of midday, especially noon.

- Take advantage of overcast days. Though many amateurs mistakenly avoid shooting when there's heavy cloud cover, this can be some of your most flattering light for human subjects because of its soft, even quality.

To manipulate natural light

- Use diffusion screens to soften direct sunlight.

- Use fill-flash to soften shadows and brighten up skin tones (see page 41 for a complete discussion).

- Use over-the-lens diffusers to soften overall contrast and skin texture.

- Use reflector cards to bounce light onto the subject, balancing the lighting and softening shadows.

SHOOTING WITH AVAILABLE LIGHT

Available light can come from a window, skylight, lamp, fire, candle . . . anything. It can be natural sunlight or artificial lamplight.

Pros

- As with natural light, it doesn't cost you anything to use, and there's no heavy equipment.

- Its look is completely uncontrived; there's no worry about making it appear natural, as there often is with the use of studio light or camera-mounted flash units.

Cons

- Often, available light results from different combined sources that have very different color balance.

- There frequently isn't enough available light for good, fine-grained pictures.

Here are two examples of natural sunlight. The picture above was made in the afternoon in autumn when the sun was relatively low in the sky. The picture at right was made in the summer in early evening. Notice the warm, almost glowing, quality of the light.

(Above) Sunlight; outdoors; Nikon 8008; Nikkor 35–105mm zoom AF lens; Fuji Velvia 50.

(Right) Sunlight; outdoors; Nikon 8008; Nikkor 180/2.8 AF lens; Kodak Ektachrome 100 (professional film).

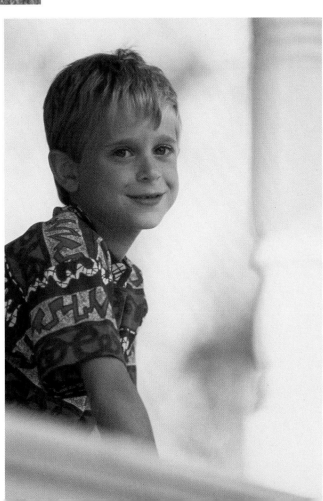

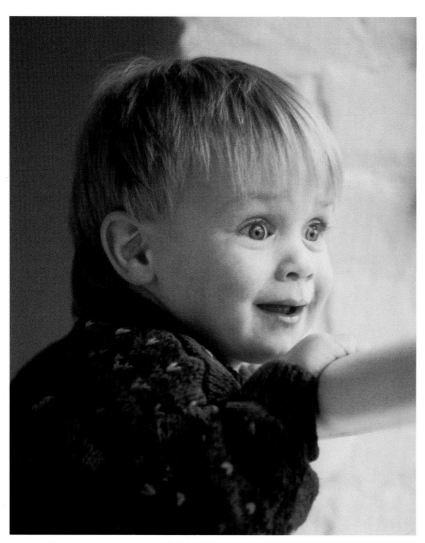
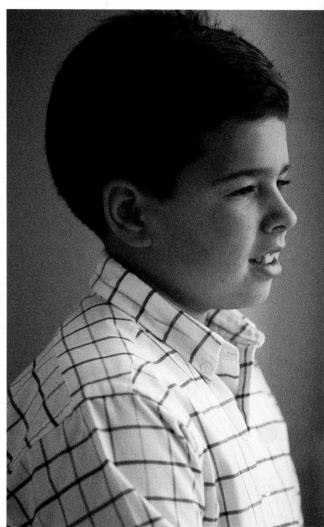

For best results

- Be aware of the color balance of common available light sources and use corrective gels accordingly.
- When available light is low, use a fast, grainy film such as Kodak 1600 Ektapress film to capture the shot, rather than resorting to direct flash, as many of us are wont to do. What you lose in fine-grained detail you'll gain in mood and beauty. If the light is very low, consider shooting a chrome film such as Fujichrome 400 professional film and push processing to gain 3 or more stops. (See page 94 for push processing information.)
- When you must augment available light, it's important to make the extra light seem natural and logical, in other words, as if it naturally existed as part of the setting. The additional light shouldn't overpower the available light, but should be the same or slightly weaker f-stop. Augmented light can mimic some other common light source, such as a window or a skylight.

To manipulate available light

- Use a camera-mounted flash unit for fill-flash or to bounce off a reflector, wall or the ceiling.
- Use portable tungsten lights, called floods or hot lights, to fill in shadows or brighten skin tones.

These portraits were both made using available window light. The boy on the left was illuminated by north light during midday, providing a soft contour on his face. The second boy was near a south window in the afternoon, which gives a more directional light.

(Far left) Available light; warehouse; Nikon 8008; Nikkor 108/2.8 AF lens; Fuji Velvia 50.

(Left) Available light; studio; Nikon 8008; Nikkor 180/2.8 AF lens; 3M Scotch 1000 (chrome film), push processed 1 stop.

- Use lens-mounted color corrective gels to neutralize yellow tint in tungsten-lit shots and green tint in fluorescent-lit shots.

Electronic flash makes shots possible when the light level is too low to make them any other way. It can be used to raise the overall light level or to fill in shadows on the subject's face without overpowering existing light.

SHOOTING WITH CAMERA-MOUNTED OR HANDHELD FLASH

Pros

- There's always enough light (provided your subject is within the recommended range), so you never have to miss a shot.
- You can use it to freeze action.
- It's lightweight, battery-operated and easy to use anywhere, especially in comparison to studio strobe units. Rechargeable batteries can be used with some units.
- It's color-balanced to approximate daylight for use with daylight film.
- It creates a softer, more natural effect if it's bounced off another surface such as a wall or the ceiling rather than being aimed directly at the subject.

Cons

- Direct flash can be very hard and unnatural looking, creating undesirable shadows, washing out skin tones, flattening the overall appearance of a picture and destroying detailing areas of highlights.
- Most amateur and some professional cameras have their flash mounts too close to the lens, which causes the light to enter the subject's eyes and bounce directly back at the lens, creating what is commonly know as red eye.
- It cannot match the softness or subtlety of natural light.
- Unlike natural light, where what you see is what you get, it's hard to visualize what effect you're achieving with flash.

For best results

- Soften flash light by pointing the unit straight up and away from the child and bouncing it off a reflector card, the ceiling or even your hand.
- Rather than using the flash at full power, which raises the overall light level and overpowers existing light, use a technique called *fill-flash* where the flash is set at approximately the same f-stop as the existing light. This will brighten skin tones and fill in shadows. Fill-flash is achieved in different ways with different cameras and flash units, so consult your manufacturer's instruction manual to learn how your equipment performs this useful effect.
- With the aid of a flash extension cord of at least three feet, detach the flash

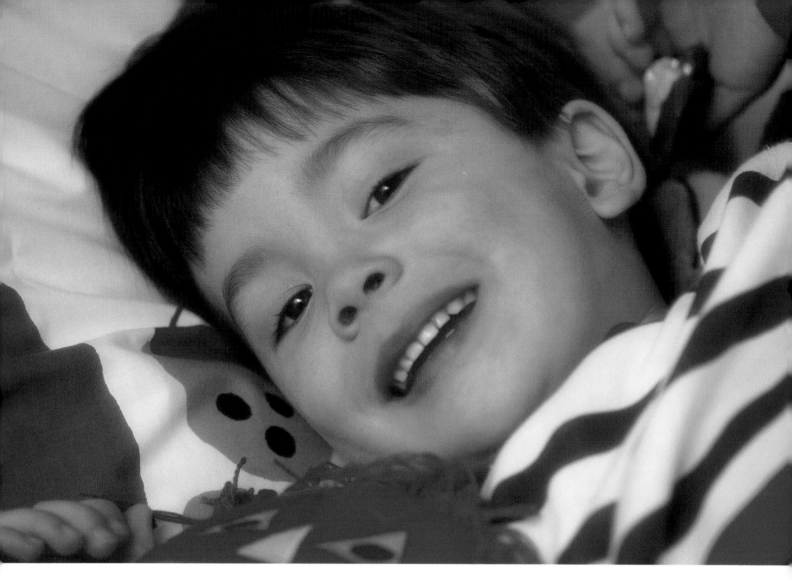

unit from the camera mount and hold it at a 45- to 90-degree angle from the subject to mimic window light. You may hand-hold the flash unit yourself, enlist the help of an assistant or mount it on a stand.

To manipulate a camera-mounted flash

- Bounce the flash off of your hand, a reflector card, the ceiling or a wall.
- Use the flash unit away from the camera, either handheld or attached to a stand.
- Use flash- or lens-mounted color corrective filters to warm and mimic available light color balance. I recommend 8 1EF, but there are many filters available. Experiment to find the ones you prefer.

SHOOTING WITH STROBE LIGHT

Professional photographers use strobe lights in the studio and on location. Strobes are much like larger, more powerful cousins to the camera-mounted electronic flash. Studio strobes require power boxes that plug into ordinary 110-watt wall outlets. These boxes commonly provide from 800 to 2,400 watt-seconds of power, which can be distributed to one, two or three or more light heads.

Pros

- There's always enough light.
- As with electronic camera-mounted flash, it freezes action.

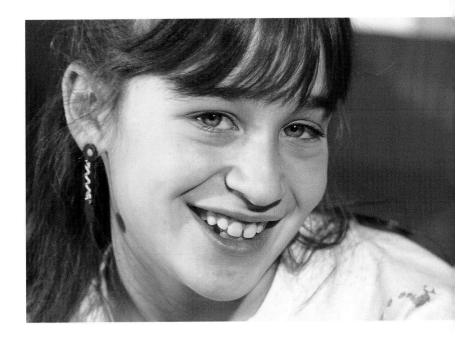

Two examples of camera-mounted electronic flash: fill-flash bounced off a wall directional; fill-flash camera-mounted and pointed directly at the side-lit subject directional. Notice how much softer the effect is than that of camera-mounted flash lighting as it is commonly used.

(Left) Available light augmented with fill-flash; indoors; Nikon FE2; Nikkor 180/2.8 AF lens; Fuji Velvia 50; #3 Tiffen soft filter.

(Right) Available light augmented with fill-flashes; indoors; Nikon FE2; Nikkor 180/2.8 AF lens; Fujichrome 100 (professional film).

- With different types of light heads, color corrective filters and reflectors, limitless lighting effects are possible.

Cons

- As with electronic camera-mounted flash, it's hard to visualize what your finished result will be. Professional photographers often rely on Polaroid tests to see what they're getting, but Polaroid equipment and film is expensive.
- The power packs and the need for electrical outlets make them awkward to take on location.

To manipulate strobe light

- Use the strobe mounted with light modifiers including white umbrellas, soft boxes, grid spots, barn doors and more.
- Use foamcore board to reflect light and black fabric or cardboard (also called gobos) to block or absorb it.
- See chapter eight for more on strobes, light modifiers, reflectors and gobos.

When photographing a child, regardless of whether you're using natural, available or studio light, your challenge usually is to capture a moving subject.

In the home a lighting setup I like is to place the subject by a window and bounce the natural light around with reflectors. The backdrop and reflectors create a comfortable little space that keeps the child more or less in position.

After much experimentation in the studio I've developed a setup that allows for some depth in the lighting, lets the child move around, and limits his movement at the same time. With this setup, the reflector and the gobo form physical boundaries that help keep the kids centered on the backdrop. I know of one photographer whose assistants hold the light heads and reflectors, and when the kid moves, so do they. Unfortunately, hiring enough assistants to do this is a luxury few of us can afford.

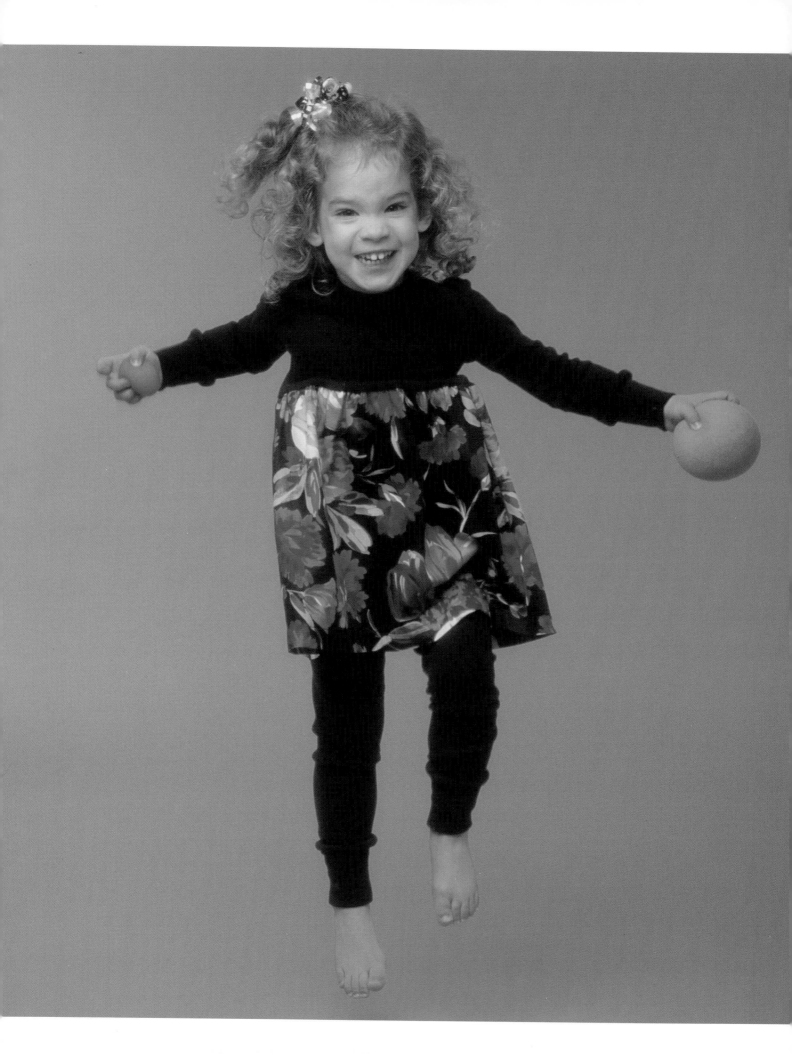

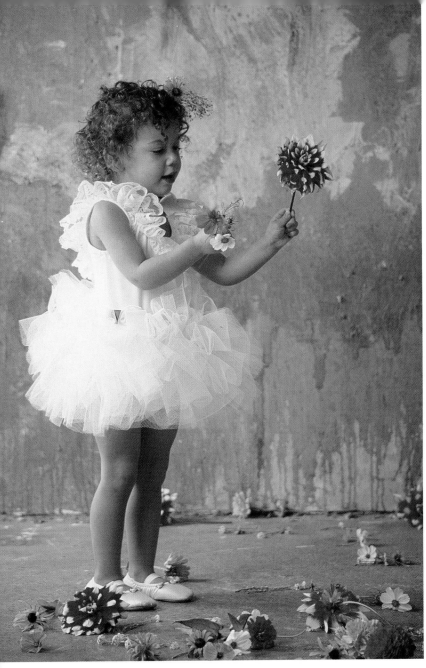

These portraits illustrate the different looks you can create in the studio with strobes. In the first shot (left) the strobes allowed me to freeze fast action; in the second (above), I used them to imitate window light; and in the third (right) to create a hard dramatic look.

(Left) Strobes; studio; Nikon 8008; Nikkor 35–105mm zoom AF lens; Kodak Plus-X (professional film); printed on Agfa Portriga 118 matte paper and hand-colored with Marshall photo oils and pencils.

(Above and right) Strobes; studio; Nikon 8008; Nikkor 35–105mm zoom AF lens; Fuji Velvia 50.

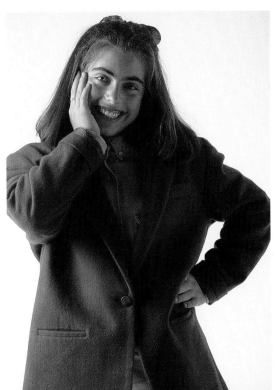

On location, however, it's easy to have one person slightly off camera hold a white or matte gold reflector and follow the child's movements. Fill-flash is also a great way to light a moving subject on location since it evens out, but doesn't overwhelm, the natural light and maintains the density of the background.

You can also use 4 x 8 diffusion screens on location (see also chapter eight). Use them outdoors both over and beside the child to soften direct sunlight. Indoors, use them as a covering on the inside or outside of a window to lessen the contrast between incoming natural light and the light in the rest of a room.

**COMMON
LIGHTING
PITFALLS**

• **Don't overlight the child.** Some photographers, especially beginners, seem to fear shadows, so they overlight. Instead, let both light and dark areas enhance the contour of a child's face. As a photographer of children, you have the amazing luxury of shooting people who have no wrinkles, few blemishes, no sagging jowls and no sunken or baggy eyes, so you can well afford lighting that's more dramatic and more interesting.

• **Don't use too many light sources.** More isn't better when it comes to lighting. The best setups involve the use of only one or two light sources. The most you could possibly ever need for a full-length studio shot is three. If you use too many light sources, you could wind up with a flat picture or one with too many undesirable shadows.

• **Use reflectors instead of lights for fill whenever possible.** It's amazing how much light a simple white card can bounce: I never realized how valuable they were until I shot a wedding for a friend on a bright but overcast day. I used available light. All the candids of the guests at the outdoor luncheon looked great, but the posed shots of the wedding party showed bags under eyes and generally tired skin tones. Upon closer observation, I realized that the white tablecloths had acted as fill cards, reflecting the available light up onto the guests' faces and saving the shots.

•**Don't rely on direct flash for everything.** With a little thought and planning, you can manipulate available light or bounce your flash to create flattering and dramatic lighting.

**SETTING
EXPOSURES**

There is no one correct exposure at which to shoot a given picture. In fact, by changing exposure you can achieve an enormous range of moods with the same light.

For the greatest control over exposure use a handheld light meter instead of

Tungsten light is warmer than strobe light, which is balanced to daylight. In this shot, tungstens were used to mimic the warm light of the late-afternoon sun.

Tungsten theatrical lights; studio; Nikon 8008; Nikkor 180/2.8 AF lens; Fuji Velvia 50.

My favorite studio light setup allows the child maximum freedom of movement. My gobo and reflector do double duty by controlling light and also confining the subject to the backdrop, which acts as a security "nook."

Strobes; studio; Nikon 8008; Nikkor 35–105mm zoom AF lens; Kodak Plus-X 100 (professional film); printed on Agfa Portriga 118 matte paper and hand-colored with Marshall photos oils and pencils, artist's oils.

your automatic through-the-lens metering, which can be fooled. The following are general rules for setting exposure in different lighting situations—as usual, meant to be bent or broken as you see fit.

When your subject is isolated against a *dark background,* your through-the-lens averaging meter reads this background and thinks the picture requires more light than it really does, resulting in an overexposed shot. To avoid this, use one of these techniques: If your camera has an exposure compensation feature, stay in the automatic mode and simply set the compensation at minus ½ to 1 stop. If you don't have this feature, you'll need to go to a manual mode and use your through-the-lens averaging meter to get a reading off a medium-toned object in the shot or your 18 percent gray card placed next to the child, then set your aperture accordingly. If your camera offers both center-weighted and matrix metering, set it on center-weighted to get a reading more true to your subject.

The opposite metering techniques are used when your subject is against a *white or very bright background.* To avoid underexposing with a through-the-lens meter, set your compensation for plus ½ to 1 stop; choose matrix over center-weighted metering when possible; and as always, use a handheld meter and manual mode for best results.

If your subject has a very *dark complexion* or is wearing *dark clothing,* especially against a bright or light field, compensate plus ½ to 1 stop; use center-weighted metering or a handheld meter and manual mode.

If your subject has a very *light complexion* and/or is wearing *light clothing,* compensate minus ½ to 1 stop, use center-weighted metering or handheld meter and manual mode.

For *sidelit* subjects compensate plus ½ to 1 stop from the average through-the-lens meter reading to capture detailing the shadowed areas.

When your subject is *evenly lit from the front* and the tone of the background doesn't deviate grossly from the tone of your subject, shoot on your average meter reading from either your through-the-lens or handheld meter.

When your subject is *backlit,* compensate plus 1 or even 2 stops from the average reading from any type of meter.

When you shoot with a *zoom lens,* the amount of light allowed to enter the lens decreases as the focal length increases. You will need to set your compensation feature to allow for ½ stop more light, or set your aperture accordingly in an automatic mode, when shooting at your longest focal length.

(Left) It's easy to make skin tones sparkle and soften shadows when shooting on location by enlisting a helper to hold a white reflector card just outside the frame, aimed upward at the subject's face.

Sunlight; outdoors; Nikon N90s; Nikkor 38–135mm AF lens; Kodak E100SW (professional film).

(Right) Don't put away your camera just because it's not picnic weather! This great shot was made on an overcast day with soft, diffused light.

Sunlight; outdoors; Nikon 8008; Nikkor 180/2.8 AF lens; Fuji Reala 160 (professional film).

THE RISKS OF BRACKETING

Bracketing is the practice of shooting the same shot at many different exposures to ensure you capture at least one shot at the optimum exposure. When shooting any other subject except children, my motto is, "Bracket like crazy!" But a child's ephemeral moods, gestures and expressions make bracketing a dangerous proposition. What if you lose that one-in-a-million expression because it happened in the frame that is 2 stops underexposed? Even with automatic bracketing, your results can be iffy.

Don't panic! There are ways to ensure your exposures work:

- Use print films that have wide exposure latitudes, such as Fuji Reala and Kodak Vericolor III, so you get good results even if your metering is a little off.
- Shoot chrome film and ask your photo lab to process only the first foot or so of film so you can examine the results (this is called a *clip test*), and adjust the processing on your balance if necessary. (Read more about clip tests in chapter ten.)
- Use bounced flash, which gives you control over the exposure, looks relatively natural, always gives the subject a predictable amount of light and won't change the density of your background. Avoid using direct flash, which washes out skin tones and can make the background go dark.

HOW TO IMPROVE YOUR LIGHTING SKILLS

To improve your lighting skills, find interesting lighting situations in photographs in magazines and printed material. Study and re-create them. The photo itself often tells exactly how it was lit.

• Look at the catch lights (the light reflections in the iris) in a subject's eyes. By noting their number, position, size and shape, you can tell how many light sources were used, where they were positioned in relation to the subject and how and if they were bounced. Umbrellas cause a round catch light, within which you can frequently see the spines. Soft boxes make a square or rectangular catch light. Windows often make a vaguely rectangular, irregular catch light. Direct light makes a round, tiny catch light. Sometimes white foamcore reflectors can be seen in the eyes, as well.

• The quality of the contour on a face tells you a lot about the light sources, as well. Flat light with hard shadows under the nose and jaw usually results from a small, direct light source such as a bare strobe head. Softer, more pronounced contouring results from larger, bounced sources such as umbrellas and soft boxes. (Note: The size of the light source is relative to its distance from the subject. A large light source placed far away from the subject will behave as a small light source.)

• The angles at which shadows fall on the face give away the position of the light sources. Overhead light causes shadows beneath the nose and jaw—the longer the shadows, the higher the position of the light. Lights positioned far to one side will cast shadows on the opposite side of the face—the farther to the side, the darker the shadow.

Some lighting setups you can re-create are included in chapter twelve.

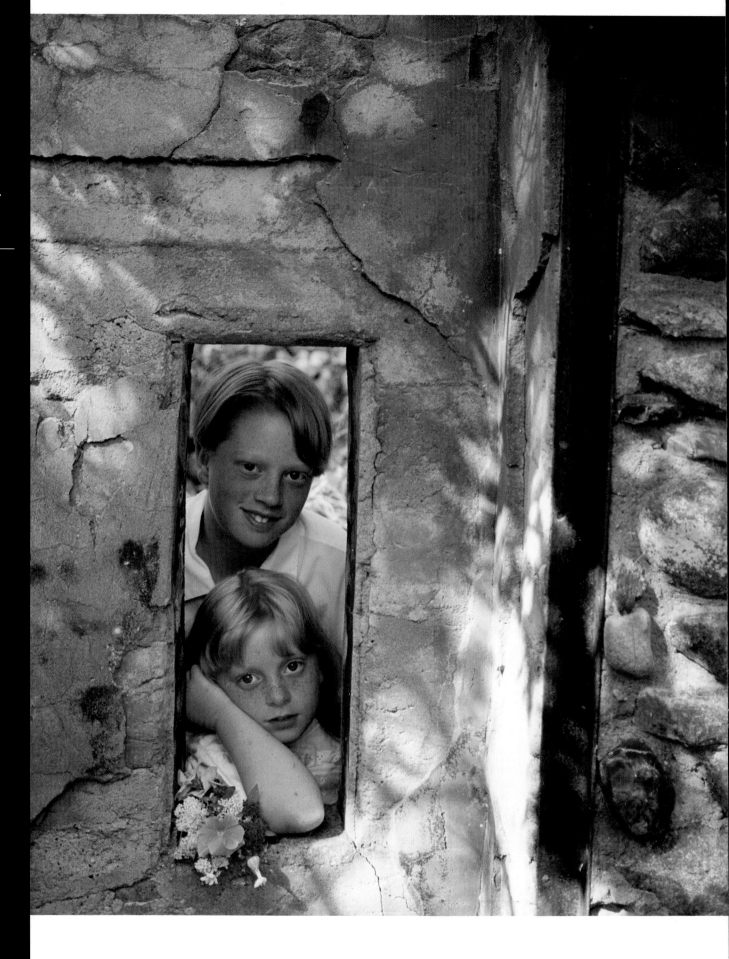

If you ask kids where they would like to be photographed, they'll give you plenty of great ideas. My niece and nephew suggested this abandoned, burned-out foundation of a twenties speakeasy.

Sunlight; outdoors; Nikon 8008; Nikkor 180/2.8 zoom AF lens; Fuji Reala 100 (professional film).

When shooting on location (not in a studio), chooses a place that tells something about the child's interests: the zoo, a fire station, a farm, a campsite. If you run out of ideas, ask your young subject for some—he's bound to have more than a few!

Scout out the location, looking for backgrounds that are photogenic, add interest to the shot, flatter but don't compete with your subject and work for your lighting plans. Foliage, buildings, fences, fountains and sporting events can all provide good backgrounds. Or just let the child go where he likes and follow him around. He'll find places that he'll be comfortable in, and you'll capture some great expressions as he explores his new environment.

One way to guarantee that the background won't overpower your subject or look cluttered is to use a lens with a long focal length (105 to 180mm), or use your regular lens at its most open aperture. The objects in the background (and the foreground) will be rendered in soft focus, so even if the location is cluttered or complex, the subject will be separated from the field.

When you're shooting at home, use backgrounds that are near windows so you can shoot with natural light. Isolate the child against a bare wall, in front of a window, in his bed, and amid his toys or collections. If he's playing on the floor, stand up on a piece of furniture and shoot down on him to eliminate background clutter. Follow your child out into the yard to take advantage of sunlight or open shade, the swing set, the garden and all of nature's wonders.

Watch for electrical outlets, switch plates, garden hoses and other common household objects that would be distracting if included in the picture. It's easy to forget about these little things because we see them every day and so become blind to them. But if they crop up in a shot right over little Johnny's head, you'll wish you'd paid attention. When you photograph a child in his home, you have the advantage of the comfort he feels being on his own turf, and you'll be able to capture natural expressions most easily. It can also contribute to the sentimental value of a picture when the child is portrayed in his own environment. You also have the option of using a mini backdrop to create a professional studio look in the child's home.

Foliage and architectural elements provide good backgrounds. Notice how, in this picture with a train background, the focal length of the lens visually lifts the subject off the field.

Overcast day; outdoors; Nikon 8008; Nikkor 180/2.8 AF lens; Fujichrome 100 (professional film).

The child's own home can provide many suitable backgrounds. This shot made with a wide lens places the subject almost comically in the foreground while capturing his bedroom in the background.

Available light augmented with fill-flash; indoors; Nikon 8008; Nikkor PC 35mm lens; Kodak Ektachrome 1600 (amateur film).

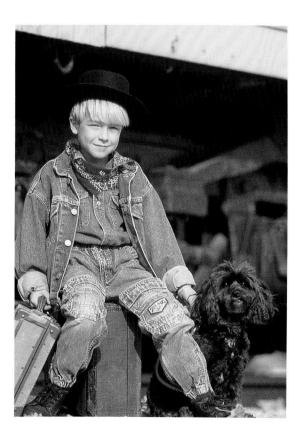

BACKDROPS FOR THE HOME STUDIO For shooting in homes and on location, backdrops should be no larger than 6 x 8 feet primarily because transporting larger ones is awkward. A plain or patterned sheet, a few yards of fabric, or a large, colored piece of poster board can all be attractive backgrounds for head shots. These mini drops can be taped to the wall with artist's or photographer's tape (available at art supply stores), or they can be hung from homemade or commercially available portable backdrop holders. (See page 58 for information on backdrop holders.) For easy storage and transportation of mini drops, tape one end around an appropriately sized wooden dowel. These can be hung unrolled in a closet between uses or rolled up around the dowel to transport without wrinkling.

An enormous range of backdrops is available for studio use, providing different colors, textures and tones to complement your subjects. Some are disposable; others are durable. They range from the simplicity of white seamless paper to impressionistic, mottled canvas to literal depictions of granite facades, street scenes or meadows.

Remember when you're shopping for backdrops:
- Colors and texture should enhance the subject (especially skin tones) and not distract from the clothing.

**Follow the child around as he explores his environment.
You'll be rewarded with shots like this one taken at a
maritime museum in Maine.**

Available light; partially enclosed; Nikon 8008; Nikkor
35–105mm zoom AF lens; Kodak VPS III 160 (professional
film).

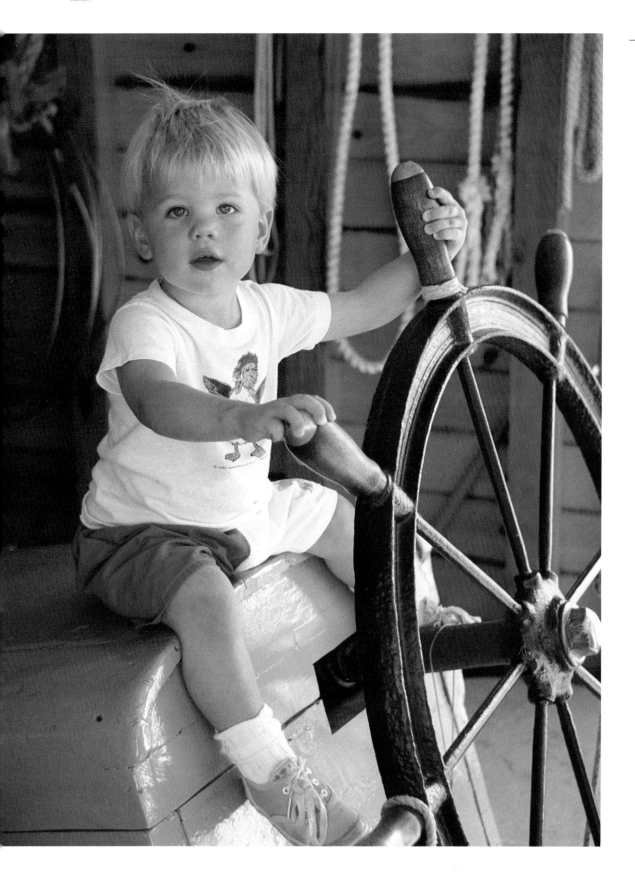

The urban-looking, weathered wall adds interest without distracting from the subject.

Overcast day; outdoors; Nikon 8008; Nikkor 180/2.8 AF lens; Kodak Ektachrome 1600 (amateur film).

- Size should be appropriate to your shooting needs. Full-body action portraits should be shot on a drop no smaller than 9 x 22 feet. Head shots should be photographed against a drop at least 4 x 5 feet for individuals or 5 x 8 feet for multiple subjects. The effect created by the drop should not appear contrived or clichéd; for instance, I personally think that literal depictions of skies, environmentals and scenics should be left for location work.

When selecting backdrops for the studio, be aware of what the look of your drop says to people—what seems fresh or friendly to you might strike others as overly commercial, "photo mill," old-fashioned, etc. Study different backdrop styles through the years. See what other local studios are offering in the way of backdrops. And beware of trends—don't play follow the leader.

WHERE TO BUY OR RENT BACKDROPS Ordinary seamless paper is the least expensive backdrop, comes in many colors including white, pastels and brights, and can be purchased from your professional photographic supplier. Stock drops, such as mottled canvas, are available from photographic supply houses and mail-order manufacturers that cater to portrait photographers. Check display and classified ads in photographic trade periodicals. If you live in a metropolitan area, you may find local artists and set designers who sell ready-made canvas drops.

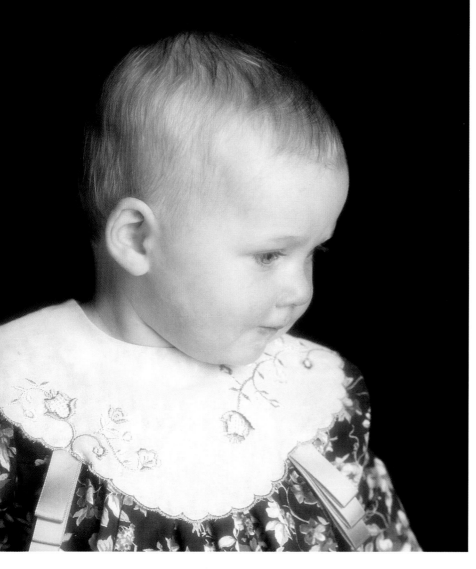

Smaller versions of most of the studio backdrops described on page 58 ("Recommended Backdrops") can be used in the home. Here, a piece of black velvet is an easy-to-use, flattering background.

Strobe; indoors; Nikon 8008; Nikkor 180/2.8 lens; Fuji Velvia 50; #1 Tiffen soft filter.

Working closely with a local artist who specializes in backdrops is ideal, but you also can order custom-made backdrops from mail-order manufacturers. If you need a special backdrop that you'll only use once or twice, renting may be the answer. Backdrop manufacturers usually stock popular styles for rental, and you even can order custom-made backdrops (usually at half the purchase price).

The same supply houses that sell backdrops through classified ads in photography magazines also frequently offer their products for rent. Frequently their rental price includes shipping and three days' usage. Locally, check with professional photographic retailers and rental houses. Even if they don't carry rental drops, they should be able to refer you to someone who does.

Some photographers elect to paint their own backdrops to save money and have total artistic control. For inspiration, browse mail-order backdrop catalogs. For specific instruction on painting techniques, your library should have books on theatrical scenic painting, theatrical set building and faux finishes.

PAINT YOUR OWN DROP

As in all things, start out with the best materials: seamless cotton muslin, duck cloth or canvas (the most durable), latex paints, natural sea sponges, cotton rags and good-quality brushes.

ALTERNATIVE You don't necessarily need giant canvas drops or seamless paper for every picture.
DROPS Head shots can be featured against solid or patterned fabric or rugs; plain, unpaint-
ed sheets or muslin (use your imagination to drape the fabric for added texture);
black velvet; layers of torn or wrinkled paper—almost anything you can think of.

BACKDROP Most of the photographers I know (including myself) have makeshift backdrop
HOLDERS stands, slapped together from broom handles, old light stands, rope and pulleys—
you name it.

Portable, easy-to-use background holders are available, manual or motorized,
that can hold one to four drops. If you never leave your home or studio, you can
probably get by with a homemade model. But if you shoot in other people's home,
as many child portrait photographers do, you'll want professional equipment. Ask
at your professional photographic supplier for catalogs and information, or check
publications for classifieds from mail-order houses.

RECOMMENDED BACKDROPS

I use the following backdrops and find them indispensable in my commercial and portrait work with kids:

• White seamless paper, 9 feet wide. Fully lit, it's naturally white. Lit approximately 1 stop less than the subject, it is pale gray. Lit with lights covered with colored gels, it can be any number of colors.

• Medium dark, warm-toned brown, mottled canvas backdrop, 12 x 24 feet. With different lighting it appears light to dark, heavily or softly mottled. It is flattering to skin ones and most clothing colors.

• Black velvet, 4 x 8 feet. A beautiful, dramatic backdrop for head shots.

• Assorted pastel and bright color seamless papers, 9 feet wide. Inexpensive and easy to store, these papers are used for portraiture and commercial shooting.

• Wrinkled, unpainted cotton muslin, 10 x 20 feet. Ideal for draping for different effects.

• Assorted fabric, approximately 4 x 9 feet. Provides a range of looks and colors from old-fashioned or retro to contemporary.

• Whether you're selecting drops for full-length or head shots, for the studio or home, remember that your background should first and foremost complement your subject.

These four photos show the backdrops I use most often in my studio (clockwise from top left): colored seamless paper, white seamless paper, wrinkled muslin and a mottled brown canvas.

Strobe; studio; Nikon 8008; 35–105mm zoom AF lens; Fuji Velvia 50.

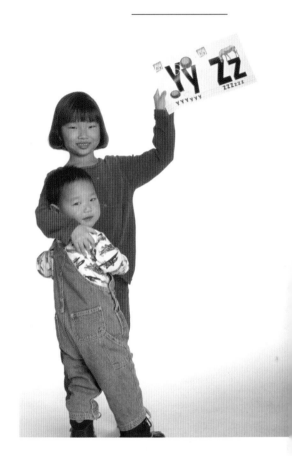

This whimsically styled shot was created as a portrait for the family's home and was also later used on a holiday card with the legend, "Have a Magical, Mystical Christmas."

Strobes; studio; Nikon FE2, Nikkor 35–105mm zoom AF lens; Kodak Plus-X (professional film); printed on Agfa Portriga 118 matte paper and hand-colored with Marshall photo oils, pencils and artist's oils.

In photographic jargon, to *style* a picture means to create, procure and arrange clothing and objects to appear in the picture. As a portrait photographer, you may select backdrops, furniture, props and clothing to enhance your portrayal of your subject. As a parent/amateur photographer, though you might not have thought of it in these terms before, you style your candids. Even the simplest shots—say, of a naked baby—are styled.

A commercial photographer styles a shot for maximum visual impact and surprise. More often than not, the objective of a commercial photo is to sell a product. When a child is featured in this type of work, the shot is styled so the child flatters the product.

Conversely, with portraiture, objects are chosen to flatter the child. A favorite toy (no matter how ragged) might soothe her, lend sentimental value to the portrait and provide simple visual interest or a more pleasing composition.

A portrait photographer might also benefit from styling designed to achieve the element of surprise or whimsy. Handing a child a new object a second or two before you shoot can capture genuine moments of surprise. Items as simple as pennies, sea shells, balls, flowers, blades of grass or bells evoke expressions of sheer wonder and delight. Tiny objects such as a penny barely read at all in the finished photo and are used solely to evoke an expression. Larger objects can be used to add color, texture and strong graphic elements.

CHILD AS STYLIST

I always encourage parents to bring at least three different outfits to the studio and to let the child select what she wants to wear. Some of the photos with the best artistic impact have been styled by the children themselves. Who else but a child would put together a flower girl dress, high-top sneakers, heart-shaped sunglasses and a soccer ball? In addition to creating great visual interest, allowing the child to style her own shoot also makes for a better portrait as it literally portrays the child's personality and interests.

One mom who scheduled a photo session at my studio called me thinking she had a problem. It seemed her eight-year-old son wanted to bring his tux and his new

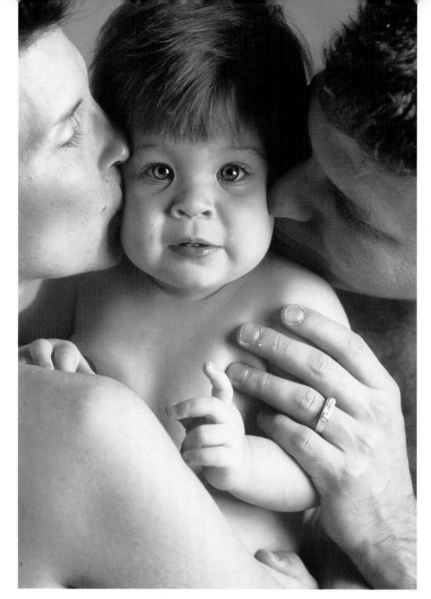

(Right) This boy came to his photo session in Western duds. The scenery was added with artist's oils after the shot was made.

Strobes; studio; Nikon 8008; Nikkor 35–105mm AF zoom lens; Kodak Plus-X 100 (professional film); printed on Agfa Portriga 118 #2 contrast paper; hand-colored with artist's oils, oil pastels and oil-based pencils.

(Left) Even a simple shot such as this was styled so it would be compositionally pleasing.

Strobes; studio; Nikon 8008; Nikkor 180/2.8 AF lens; Fuji Velvia 50.

dress suit to the shoot, while her twelve-year-old refused to wear anything but sweatshirts and jeans. She wanted to know if she should force a compromise and make them each wear complementary clothing in the shots of the two of them together because she was afraid they wouldn't "match." I encouraged her to let them wear whatever they chose, to let their personalities come out instead of being concerned about matching outfits. The resulting photos are some of my favorite to date.

If you decide to allow the child to be your stylist, give her carte blanche to choose anything she likes. The results won't be pleasing to either of you if you say, "Okay on the cowboy outfit, but eighty-six those funny-looking chaps." We've had success with fairies, cowboys, pumpkins, bunnies, spiders and more. Trust the child's sensibilities completely. You may be afraid costumes will detract from the goal of a portrait. But dress-up is a big part of a child's life, and just as adults sometimes seem to find it easier to "be themselves" when disguised at a costume party, so is a child very much himself in a costume.

PLAN AHEAD The old Boy Scout motto, "Be prepared," really applies to photographic styling. There's nothing worse than the sinking feeling you get when you realize, "Gee, if only we'd had Susie's security duckie, this could've been a great shot," or, "We need

The little yellow toy did double duty in this portrait: It was the youngest brother's security toy, so it lent sentimental value, and it added just the spot of color that was needed.

Strobes; studio; Nikon 8008; Nikkor 35–105mm zoom AF lens; Fuji Velvia 50.

just a spot of color here; too bad we don't have anything." For portrait sessions I always ask parents to bring any and all favorite objects, from toys and books to sporting goods and musical instruments. I've had people show up at the studio with suitcases full of stuff. Some of it we use, some we don't. But my clients agree with me when I say that it's better to have too many options than not enough. I always keep an assortment of photogenic balls, hats, flowers and toys at the studio. And I always try to use the child's own objects in portraits whenever possible, but sometimes a strange new toy charms the child into a more playful mood.

For commercial work and other more elaborate setups, I plan out the shot in my mind and then bring along anything I think might even remotely come in handy. At any given moment the hatch of my car might contain antique Coca-Cola crates, colored scarves, bales of hay, inner tubes, carved coconuts—anything.

BUT HANG LOOSE Now that I've told you to plan ahead, I'm going to contradict myself and tell you to "hang loose" as well. It's important not to be too rigid nor to have your shoot too thoroughly planned, or you may become oblivious to serendipitous objects in your environment that may make all the elements of a really great photo come together. For instance, I was on location in downtown Minneapolis shooting a five-year-old "puppy yuppie" in a Brooks Brothers blazer with loafers and no socks, a *Wall Street Journal* under his arm and wire-rimmed glasses. I had planned to shoot him on a busy street with a yellow cab in the background. As it happened, this was easier said than done. Cabs in Minneapolis seem to come in blue, white, blue and white, gray—any color but yellow. When I finally found a yellow one and positioned my subject in front of it, I became annoyed when I discovered a ten-speed

This girl did her own charming and surprising propping for this portrait, which hangs in the family's entryway at home.

Strobes; studio; Nikon FE2; Nikkor 35–105 zoom AF lens; Kodak Plus-X (professional film); printed on Agfa Portriga 118 matte paper and hand-colored with Marshall photo oils and pencils, and artist's oils.

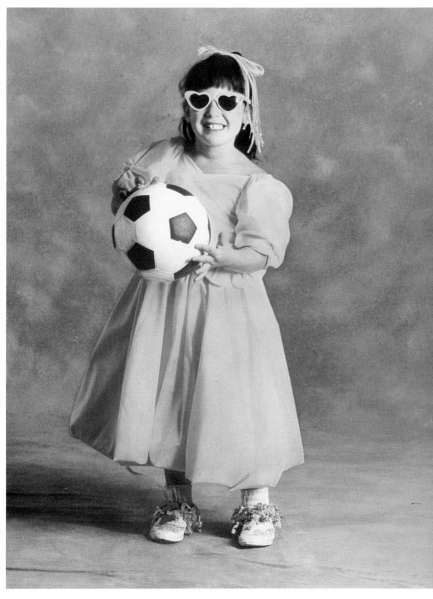

Plan ahead for your props and styling, but don't be so rigid that you fail to take advantage of dumb luck. In this shot, a bicycle that happened to be at our location added a great compositional element and enhanced the urban feeling.

Sunlight; outdoors; Nikon 8008; Nikkor 180/2.8 AF lens; Kodachrome 200 (professional film).

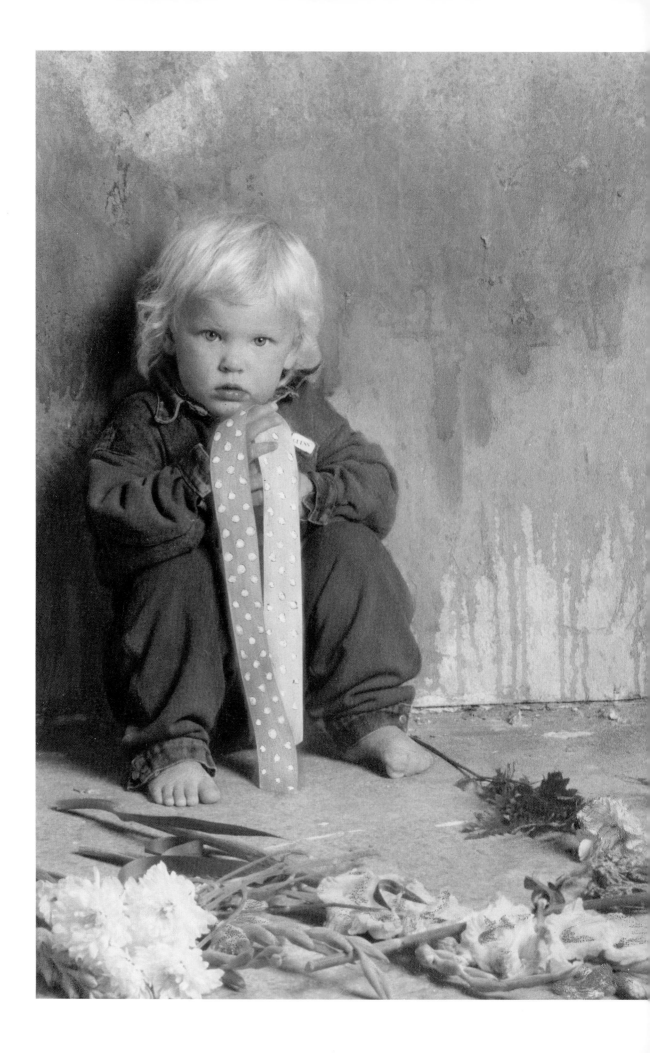

**Scattered flowers and a bright ribbon add color and
heighten the pensive quality of this shot.**

Strobes; studio; Nikon FE2; Nikkor 35–105mm zoom AF lens;
Kodak Plus-X (professional film); printed on Agfa Portriga 118
matte paper and hand-colored with Marshall photo oils and
pencils, and artist's oils.

locked to a street sign in my frame and began thinking out ways to shoot around
it. Then as I was considering this, the subject's mom said, "That bike would look
kind of neat in the shot, wouldn't it?" Bingo.

You don't need to search for clever or ridiculous props to add the unexpected to
your photos. Sometimes objects that traditionally appear in photos of children can
seem new and exciting when handled differently. Consider these common objects:

ORDINARY
PROPS IN A
NEW LIGHT

• Flowers are often seen in pictures of pretty little girls in frilly dresses. But
what if the girl were dressed in jeans, throwing the flowers up in the air, holding
them dropped casually at her side, as if she's forgotten them, or standing amidst
them scattered on the floor? Give the (nonpoisonous) flowers to a baby or toddler
to hold, but stand close by to retrieve them in case your subject decides they look
good enough to eat. A small child will most assuredly do something unconventional
with them, such as playing "sword fight" or pulling them apart, and you'll have a
whimsical photo. Use unusually large flowers (sunflowers, giant tulips, and bird-of-
paradise flowers are good) to emphasize the smallness of a child. Use wildflowers
or flowers from your own garden instead of the showy, more obvious store-bought
hybrids for an unexpected look. Wrap the stems with ribbons or tear off the stems
and tuck the blossoms into socks, pockets, hair, up sleeves and in collars. Let the
child peek through the flowers into the camera.

• Hats and toddlers might result in any number of things. A child might hold it,
wave it, stand on it, toss it up in the air, play peek-a-boo behind it, pull it down
over her ears, put it on upside down . . . the list goes on. The hat could be too big
or too small. It could be a fireman's hat, a baseball cap, or a paper crown of the
child's own making. The child could don lots of hats in a stack. Sometimes a hat
simply held in the hands can add a striking graphic element.

• Musical instruments are endlessly intriguing to kids, as well as being objects
of beauty in their own right. The child doesn't have to be a virtuoso to be pho-
tographed with a musical instrument. He doesn't even have to know how to hold
it. Shots of the child exploring a shiny trumpet or a violin and trying to play it can
be charming and revealing of the child's personality.

• Ribbons can be fixed into a little girl's hair, of course. But she could also wave
them in the air like streamers, dance with them, tuck them into a pocket, hold down
a bunch of them like a bouquet or wind herself up in them.

• Sunglasses can be worn in the conventional way and peered over, tucked into
the front of a shirt or pushed back up onto the head. One girl at my studio man-

aged to wear a record six pairs at once. Take care not to shoot too many pictures of the kid wearing glasses. They are a lot of fun, but they cover up one of the most interesting and expressive of facial features—the eyes.

• Sporting equipment of almost every type has been inside our studio, but it takes a little extra care to compose with. Skis are hard to fit into a pleasing composition; overeager skaters can fall down; balls and bats are hazardous near cameras and lighting equipment. But it's well worth the extra energy and caution to portray the child with the uniforms and equipment from her sport(s) of choice because the zeal and sincerity she pours into its pursuit will be evident in the picture. If a child is active in several sports, photograph her holding equipment and wearing parts of uniforms from all of them.

This little violinist was eager to include her instrument in her portrait.

Overcast day; outdoors; Nikon 8008; Nikkor 180/2.8 AF lens; Kodachrome 400 (professional film); push processed 3 stops.

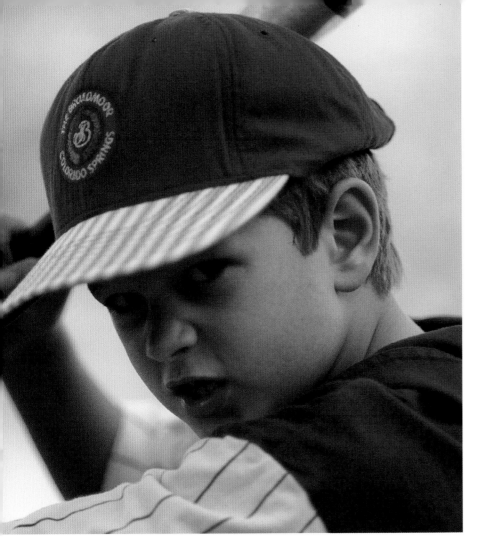

Sporting equipment can give the child something to do in a portrait and tells you about his interests.

(Left and below) Sunlight; outdoors; Nikon N90s; Nikkor 38–135mm AF lens; Kodak E100SW (professional film).

Ethnic identity portraits help us stay in touch with our roots and emphasize our uniqueness. Anyone can have an ethnic identity portrait made; we all belong to ethnic groups.

(Left) Strobes; studio; Nikon 8008; Nikkor 35–105mm zoom AF lens; Fuji Velvia 50.

(Right) Tungsten theatrical lights; studio; Nikon 8008; Nikkor 180/2.8 AF lens; Fuji Velvia 50.

• Ethnic objects and clothing are integral to what I call "ethnic pride portraits," in which children born in the U.S., abroad, adopted or living with their biological families, don clothing and hold objects representing their ethnic heritage. I became interested in making ethnic pride portraits after reading about a new Afrocentric school in Minneapolis. When my clients booked their portrait sessions, I invited them to bring along any ethnic outfits the children might have. I found that both the parents and the kids loved the idea, and most of them owned such outfits. A child needn't be a member of an ethnic minority to make an ethnic pride portrait.

• Toys, particularly a child's favorites, both calm and entertain the child while providing an evocative portrait element. The older, dirtier and more ragged the toy, the better. I believe in years to come the presence of such an object in a portrait will give it inestimable value to the child and later generations. In portraits and commercial pictures, old worn toys can be infinitely more beautiful than new. New toys just don't have the character, texture and warmth of the old. Consider scouring antique shops for teddy bears oozing stuffing, yellowed toy drums, bashed-around metal trucks, old-fashioned baby buggies, bikes and anything else that catches your eye.

• Parents as props can make an individual portrait into a unique family portrait. A young dad once called me to make an appointment for a shoot three months in advance of his son's one year birthday so he could be sure to get the child's photo taken on the exact day. The family called me specifically because they wanted our specialty—full-body action shots. "I'm sure he'll be walking by then," the dad told me right before he hung up.

As fate would have it, the boy, a beautiful little redhead, wasn't even quite standing by himself, let alone walking. We tried standing him up on the seamless and stepping out of the shot at the last second, but he wilted to a sitting position every time. I suggested a family shot so the parents could help him stand up by holding his hands, but they would have none of that. "What about photographing you two from the waist down?" I meant it as a joke, but then I thought, "Why not?"

(Above) Medical devices are appropriate in portraits of physically challenged kids whose quality of life is enhanced by them.

Available tungsten and fluorescent light; one tungsten "hot light" bounced off the ceiling; Nikon 8008; Nikkor 35–105mm zoom AF lens; Kodak 1600 Ektapress (professional film).

(Right) Parents can be literal or figurative props in pictures of their offspring.

Strobes; studio; Nikon FE2; Nikkor 35–105mm zoom AF lens; Kodak Plus-X (professional film); printed on Agfa Portriga 118 matte paper and hand-colored with Marshall photo oils and pencils, and artist's oils.

The resulting photo uses the parents quite literally as props. It shows how tiny the baby's hands are compared to those of his parents, and an aspect of the relationship between family members.

• Makeup never makes a child look better because children are naturally beautiful. Makeup frequently gives photos a dated or "Hollywood" look. Costume and stage makeup, clown-white and glitter, though, can be fun and playful.

• The right clothing can enhance a portrait. There's something inexplicably cute about a kid in a rain slicker and rubber boots. Likewise, a cloth coat, fake fur, a muff or mittens.

A portrait of a child in mom's or dad's clothes is more than just cute—it also captures a universal experience of innocent play.

We've made many pictures of kids in their night clothes. It's a look parents love to capture on film. Sometimes we invite the kids to have pillow fights for the camera … you can probably imagine that we don't have to ask more than once.

Another favorite of parents is to make portraits of their kids in bathing suits, often with beach balls, sunglasses and Mickey Mouse inner tubes. It's a fun way to capture those round little tummies, chunky knees and chubby toes.

• Messy hair, missing teeth, torn tights, holes in pants' knees, missing buttons, falling straps and untied shoelaces are some of my favorite props. I take advantage

Swimming suits are a refreshing change from the dressy look of formal portraits and are fun for the kids to wear.

Strobes; studio; Nikon FE2 Nikkor 35–105mm zoom AF lens; Kodak Plus-X (professional film); printed on Agfa Portriga 118 matte paper and hand-colored with Marshall photo oils and pencils, and artist's oils.

These hand-colored shots use creative styling to highlight the child's natural grace and exuberance and stretch the conventional concept of portraiture.

Strobes; Nikon FE2; Nikkor 35–105mm zoom AF lens; Kodak Plus-X (professional film); printed on Agfa Portriga 118 matte paper and hand-colored with Marshall photo oils and pencils, and artist's oils.

of these things when they happen naturally, but I never contrive them. Most of my clients are in agreement with me on this, but some still want the kids to look picture-perfect. One mom scheduled a photo session and then called back to cancel it because her little girl had lost a tooth. She wasn't going to have another professional portrait made of her until she had all her adult teeth. What a shame! Missing teeth are a natural part of childhood. If everyone shared that attitude, then five hundred years from now, anthropologists looking at photographic records of our culture might think kids between six and twelve didn't exist.

• Birthmarks, freckles and other permanent features, which I consider a part of each child's beauty and individuality, should be included in portraits. On the other hand, while measles, chicken pox, bruises, bug bites, blemishes and the like are also natural parts of childhood, I have no qualms about retouching these out of a photo.

• Medical devices that are used by physically challenged kids are also appropriate props. I believe portraits should portray their subjects as individuals and not try to make us all look the same or fit into the same mold. Therefore, when I shoot kids who are physically challenged, I don't try to make them look like able-bodied kids. They are beautiful as they are. And I don't try to hide or downplay any medical devices such as respirators and wheelchairs that help the kids get around and improve their quality of life. I believe it's important when making portraits of all kids to respect and to honestly represent all the qualities that make them unique.

Of course there will be times, like when you're shooting candids, when you won't have the opportunity to be picky about the objects or clothing of your subjects; sometimes when you see a great moment, you just have to shoot! But when you have the opportunity to plan or the presence of mind to take advantage of a little serendipity in your environment, it can pay off big.

The equipment you choose greatly affects the type of photos you make. Here, a combination of strobe lights, autofocus camera and a mid-length lens allowed me to freeze the action of this self-confident cowboy. A weaker light source or a lens with a long focal length might jeopardize a spontaneous shot.

Strobes; studio; Nikon 8008, Nikkor 35–105mm zoom AF lens; Kodak Plus-X 100 (b&w professional film).

I once met a photographer who had an unbelievably impressive array of photographic equipment—many different formats, lenses, enlargers—anything I could possibly imagine ever needing. *Wow*, I thought, *this guy must be a fantastic photographer.* I asked him to share some of his work with me. He admitted, rather sheepishly, that he hadn't made a picture in several years. "I guess I'm kind of a photo gearhead," he said. He admitted to reading photographic equipment catalogs the way kids read the Sears Wish Book at Christmastime.

Personally, I'm not a gearhead, but to me, a 180mm lens really is a thing of beauty. I appreciate equipment, not for equipment's own sake, but for what I can say with it. Admiring equipment can be an expensive habit, but if you do your research and buy carefully, it can be worthwhile.

FEATURES TO GET IN A 35MM CAMERA

I find the 35mm camera perfect for the fast action of photographing children. It's lightweight, and you don't need to stop and reload after only a few shots. Unless you plan on making a lot of shots for enlarging to larger than 11 x 14, you'll never need to aspire to a larger format. And with some of the new, fine-grained 35mm film, such as Velvia 50, you can get results that rival those of larger format cameras, even at enlargements of up to 16 x 20. I use a Nikon N90s for almost all of my child photography. Although Nikon promotes it as their top-of-the-line amateur camera, it's popular among amateurs and pros alike. But Nikon isn't the only manufacturer that makes great 35mm cameras. You can make great pictures of kids with any brand of camera as long as it's equipped with these features:

- **Autofocus** for the quickest possible response. Autofocus features are becoming more sophisticated all the time. Models are available that can track moving subjects, anticipate the subject's movements and even track the photographer's eye movement.
- **Auto and manual exposure** so you can shoot without thinking about the exposure or use artistic license in exposing your shots. Some models are available with an automatic bracketing feature.
- **Motor drive** so that you don't have to pause to advance your film.

A note to amateurs: If the thought or price of a camera body with interchange-able lenses scares you, don't worry. Just get a good-quality point-and-shoot with a long zoom lens, again, preferably in the 35 to 105mm range. While the long zoom feature dramatically increases the price over other point-and-shoots (expect to pay around $250), the results are well worth it.

BEST LENSES FOR PHOTOGRAPHING CHILDREN

For photographing children, there are two invaluable 35mm format lenses: an approximately 38 to 135mm zoom and a fixed 180mm. Both are available from all manufacturers. The zoom allows you maximum latitude in framing your shots; from one position you can compose everything without being intrusive. I use the 38 to 135mm zoom mainly in the studio to capture full- to three-quarter-length action shots.

The fixed 180mm makes it even easier to photograph kids unnoticed. Its most important feature is its ability to keep the subject in sharp focus with minimum distortion while making the foreground and background soften into unfocused shapes and colors. While longer focal lengths, such as 200mm and even 300mm, provide more softening of the field, they necessitate being very far away from your subject when you shoot, which limits their versatility. I almost always use the 180mm lens for shooting outside the studio and for head shots in the studio.

As sort of a hobby, I like to read the ads in the newspaper classifieds for used photo equipment. It seems as though used 180mm lenses are almost never available. This leads me to believe that once photographers use one, they never want to part with it.

When using the 180mm is impractical, but I still want a softer, more abstract background, I shoot with my zoom lens on its most open aperture (3.5) for its shallowest depth of field.

Don't try to skimp with a cheap lens. If you do, you're guaranteed to regret it. Decide what type, fixed or zoom, and which focal length you want, and then buy the best you can afford. I use a Nikkor 38 to 135mm AF and a Nikkor 180mm AF.

MEDIUM AND LARGE FORMAT VIEW CAMERAS

Until recently, no medium format cameras were available with autofocus. That all changed with the new Mamiya 6.45. Its eye-level viewfinder and special grips make it the hands-down choice for child photographers. It is still not quite as comfortable to use as a 35mm, and you still have to change film backs, but what you give up in speed you gain in grain—with a negative three and a half times larger.

The 4 x 5 format cameras require more light and are heavier and more cum-

bersome to handle than 35mm or medium format cameras, which makes it more difficult to shoot active kids, especially in low light. They have to be mounted on a tripod, so there is no hand-holding option here. No 4 x 5 cameras that I know of have autofocus features. But there are some beautiful effects that can be created only with a 4 x 5 view camera; and if you're after fine grain, a 4 x 5 negative, at three to five times the size of a 35mm negative, provides superior results.

Another medium format camera to consider is the 6 x 7, which, while not as handy as the 6 x 4.5 models, offers a negative three and a half times the size of a 35mm negative in the same proportion as an 8 x 10 print, so none of the image is wasted. This also requires a tripod.

Square negative medium format cameras such as the Hasselblad are my least favorite cameras for photographing children. My shots are typically vertical, so I waste a large portion of the negative because of its square format, and I lose much of the tinier grain it would otherwise provide over its smaller format cousin.

I use 150mm and 180mm lenses with medium format cameras for portraiture.

Large format (4 x 5, 8 x 10 and even larger) cameras are beautifully simple devices because they are basically a movable box with a lens, shutter and a film plane. Unlike the 35mm cameras, which keep getting better and better with each new design, a large format camera need be neither new nor expensive to be good. You can pick up a virtually antique large format camera at a swap meet for a reasonable price or buy a new bottom-of-the-line model and still get good results.

I use a top-of-the-line Cambo 4 x 5 view camera with a 210mm lens for shooting kids for commercial clients. I rarely use it for portraiture, except for Polaroid color transfers.

While the large format cameras are nice to have, they're certainly not a necessity for children's portraits. Though they provide the finest grain, they're really overkill for any enlargement up to 16 x 20.

ARTIFICIAL LIGHTS

Strobes, tungsten and camera-mounted flashes are artificial lights used by photographers. I, like most portrait photographers, rely heavily on strobe units because of their consistency and ability to stop action. A good strobe unit should be dependable, require low maintenance and have a short recycle time. (For instruction on how to use lights and their pros and cons for photographing children, see chapter five.)

I use a Speedotron strobe. A local photographic equipment rental proprietor calls "Speedo" a great workhorse because it is durable and needs repair much less

MUST-HAVE EQUIPMENT

To do anything well, you need quality tools. Anyone who wants to photograph children seriously should have the tools that will make it possible to translate their style and vision into pictures. Some of the equipment on this must-have list is expensive; some is only a few dollars. If cost is an issue, begin with the items you can afford now and add items as you can. Must-haves for everyone include:
- 35mm camera with autofocus, automatic function and manual overrides
- midrange zoom lens, such as 35mm to 105mm
- bounceable electronic flash with diffuser and extension cord
- reflectors (three 32 x 40-inch white foamcore sheets and two matte silver tagboard sheets)
- gobos (two 4 x 8-foot lengths of black fabric or two 32 x 40-inch black tagboard sheets)
- diffusion filter for lens (such as #1 Soft FX Tiffen)
- Kodak 8 1EF corrective color filter for lens
- site kit

In addition to the must-haves for everyone, studio photographers should have the following:
- strobe unit, at least 1,200 watt-seconds
- three light heads
- two 40-inch white umbrellas
- two 24 x 36-inch soft boxes
- three light stands
- handheld light meter
- two diffusion screens
- extension for camera-mounted flash

Once you've acquired the must-haves, you can start compiling your wish list. Here are a few suggestions to get you started:
- 180mm lens
- Mamiya AF 6 x 4.5

frequently than either of the other two popular—and more difficult to service—brands, Norman and Balcar. The Brown Line Speedo is a good unit for amateurs with up to 800 watt-seconds (watt-seconds are units used to measure power or brightness of the light produced by strobes), and Black Line is good for pros, with special features including adjustable power from as low as 50 watt-seconds all the way up to 4,800 watt-seconds and a fast recycle time. The broad power range allows you to fine-tune your lighting.

There are many different camera-mounted flash units to choose from. Many professional photographers use a Vivitar 285. Look for a unit that's compatible with your camera. An extension cord for using the flash away from the camera and a diffuser to soften the light are accessories that make good investments.

Tungsten floods and spotlights are rarely used by portrait photographers, so most photographic suppliers carry a limited selection. If you're interested in getting a more elaborate tungsten setup, see a theatrical supplier. Different wattages are available, and many models come complete with stands.

LIGHT MODIFIERS

There are numerous ways to modify or control natural, available and strobe light at home; on location; or in the studio to produce different qualities of light, from soft and diffused to extremely directional and hard. Experiment to find what you like the best. Light modifiers may be purchased new from mail-order and local retail photographic suppliers or used from individuals or rental stores.

In general, umbrellas, soft boxes and reflectors constructed of white materials

are modifiers that provide the most flattering light for photographing children. Umbrellas and reflectors made of silver material provide more specular light, which can be uncomplimentary to skin texture and can create an unattractively cool color balance as well.

- **White umbrellas** are good, all-purpose reflectors for illuminating children and backdrops. For soft light, a large umbrella provides more diffusion. For harder light, a smaller umbrella is needed. To avoid spill (light coming off the umbrella in directions where you don't want it), buy white umbrellas with black backing material. Umbrellas are available in 30-, 40-, 45- and 54-inch sizes and are considerably lower priced than soft boxes.

- **Soft boxes** are my favorite light modifier for illuminating backdrops and children. Unlike umbrellas, which reflect light, soft boxes diffuse light to provide an effect that is soft but somewhat more directional. Some photographers object to the square catch lights caused by soft boxes, but there are new soft boxes on the market that create round and oval catch lights. Standard sizes (in inches) are 16 x 22, 24 x 43, 36 x 48 and 54 x 72.

- **Fill cards** can be made from white foamcore board or white or matte gold tagboard. Tagboard comes in 3 x 4-foot sheets, and foamcore comes in up to 4 x 8-foot pieces. Both are available at most art supply stores.

- **Diffusion screens** are useful for softening available or strobe light at home, in the studio and on location. There are many different types of diffusion screen fabrics, which provide different qualities and colors of light. I find the most useful size to be 3½ x 6½ feet because these can be used for full-length or head shots. Lightweight frames are available to hold the fabric, and they fold down into compact, easy-to-carry units. Purchase these from mail-order photographic suppliers and local retailers, or make your own diffusion screen by draping an ordinary white sheet between two light stands.

- **Gobos**, also called subtractive light modifiers, create the opposite effect of reflectors. Rather than bouncing light, they absorb it to create shadowed areas and block light from spilling. Make you own gobos from black tagboard or black velvetlike fabric. To use, position gobos just outside the frame opposite whatever subject or surface you wish to remain shadowed.

- **Diffusers** can be mounted over the lens to soften skin texture, contrast and shadows and create an interesting "flare" effect on white areas in a picture. Tiffen brand diffusers provide the slightest diffusion. Tiffen #1 is my favorite for photographing children because it softens skin texture without

lowering contrast or changing the exposure. The #3 is a good choice, as well. Softar diffusers, made by Hasselblad, are also fairly good, though they do lower contrast. Use the Softar #1. The #2 creates a somewhat "mushy" look.

Many photographers like to create their own diffusers. Start with a small square of Plexiglas or glass and apply hair spray, Vaseline or nail polish to the areas you wish to diffuse, or stretch panty hose over your lens. Caution: If you use nail polish, be sure it's dry before getting it near your lens. If you get Vaseline on your lens, carefully clean it with lens cleaning solution.

• **Lens-mounted color conversion filters** made of gelatin or polyester change all color wavelengths and can be used to alter the color balance of a photograph. Usually, in photographing children, color conversion filters are used to warm the overall effect. I frequently use Kodak 8 1EF on overcast days, in north light or when I want a sentimental or old-fashioned look.

LIGHT AND MODIFIER STANDS

Unless you hand-hold your strobe, to use any light source with or without a modifier, you need a stand for holding these components. The best and most portable light and reflector stands are made of lightweight aluminum because of the ease in carrying and transporting them. I use Bogen stands. Photographers breaking into child portraiture should consider buying at least three stands so they can use up to three light heads at one time. Sizes and costs vary. Another important piece of equipment is an 18 percent gray card. You need an 18 percent gray card, which equates to a medium tone, for through-the-lens metering indoors or outdoors so the meter isn't fooled by the intensity of a very light or very dark element in your portrait. These are inexpensive and are available at your local photo store.

PREPARE A SITE KIT

Every photographer should have a site kit that contains a first aid kit, a Swiss army knife, black electrical tape, gaffer's tape, string, a Nerf ball, a squeaky toy, processing envelopes for the photo lab, hairpins, safety pins, a cloth diaper and a bandanna. Every item has come in handy at one time or another for various purposes, both in the studio and on location.

WHERE TO BUY EQUIPMENT

New York mail-order retailers advertise in photographic magazines offering "gray market" merchandise. This usually is the same name brand equipment you purchase from regular retailers, but is imported from Europe and Japan and often comes without an American warranty. The prices can be as much as 20 percent lower than those of equipment available from American retailers. If you're a gam-

bler and can live without a warranty, you might try buying on the gray market.

Mail-order retailers that offer merchandise with American warranties often, but not always, offer prices up to 10 percent below those offered at retail stores. You can also buy used equipment very economically by mail order. This is a good option for amateurs, although used equipment comes without a warranty.

Local retailers either stock or can order almost any piece of equipment you need. Shop around to find the best price. Often, they'll reduce a price to beat a competitor or offer extras like film or accessories, especially on high-ticket items.

Used rental equipment is usually available in metropolitan areas. When equipment becomes outdated or for some reason becomes unrentable (but not unusable), businesses often offer it for sale at excellent prices. Most of it is snapped up by photographers who hear about it through the grapevine before word trickles down to the general public. So contact rental shops and let them know what you're looking for. Ask if they have a waiting list, and get your name on it.

Other used equipment can be found at professional photographers' retirement and going-out-of-business sales. Check the bulletin boards at commercial labs and photo rental shops. Watch the classifieds for swap meets where you can shop the offerings of many photographers and dealers at once. Often, you can get better prices if you purchase an entire package (camera body, lenses, film backs, etc.) rather than individual pieces.

SHOPPING FOR USED EQUIPMENT

THE ADVANTAGES OF RENTING

If there's a piece of equipment you're dying to try, here are five good reasons to rent before you own:

1. You're not sure if it will work out for you.
2. You're comparison shopping and you want to get the feel for several different brands of lights or cameras before you make the big plunge.
3. You're shooting out of town and don't want to haul several tons of gear on the plane.
4. You have infrequent need for expensive equipment for special jobs or self-assignment.
5. You're getting more interested in photography and want to explore the medium without spending a lot of money.

Learn the ropes of renting photographic equipment. Rental prices and selection can vary from place to place, so shop around. As a renter, you're liable for damage to any equipment you receive, so check it out before you leave the shop to see that it's all in working order. If the equipment becomes damaged while in your possession, you'll be charged for its repair or replacement. The staff at many photographic rental stores are often photographers and may be able to advise you about appropriate equipment for portraiture.

Sure, renting isn't ideal. You have to call in your order, pick it up, drop it off, cope when the needed equipment isn't available and do without the satisfaction of owning. But sometimes renting is the only logical solution. If you do decide to rent, here's what you should do to see that your needs are met:

• Be explicit when you phone in to reserve your equipment. Tell them exactly what you need.

• Develop a relationship with more than one rental shop in your city so that if one doesn't have what you need, you can try another.

• Check all the equipment at the rental shop when you pick it up to see that it's all there and in working order.

The relatively high speed of Kodak Tri-X 400 professional film allowed me to capture this humorous and joyful moment. Because of the archival properties of black-and-white film, this boy's children will be able to enjoy this picture—and perhaps even their children.

Indoors; available light; Nikon 8008; Nikkor 180mm AF lens; Kodak Tri-X 400 (b&w professional film).

There have been enormous innovations in photographic film since 1993, when the first edition of *Creative Techniques for Photographing Children* was published. As always, the industry has striven toward finer grain at faster and faster film speeds, allowing amateur and professional photographers alike to capture the clearest, most detailed images while taking better advantage of natural light and small formats. Many of the 400 speed films available today boast as fine or finer grain than 200 speed films of eight to ten years ago.

Also, in 1993, the very first supersaturated color films, Reala C-41 and Velvia E-6, both from Fuji, had just hit the market. Initially they were regarded warily by photographers and critics who valued accuracy over impact. What possible use could there be for a film that "records" colors that aren't even there? But as photographers have gravitated toward these new films that gave us more beauty, more visual bang for the buck, they have almost become the norm. Now there are many supersaturated films available from different makers.

There are now more films and film types to choose from than ever before. And film is just your raw material; different processing and printing techniques and materials stretch the possible interpretation quality, and longevity of your finished photographs almost to infinity. So where to start?

If you have the luxury of time and money, test shoot many different film types. Then pick the films that give you the look you love and stick to them. Use the film to help shape your personal style and your approach to a given photo session. For instance, if you have low light and a small format camera, don't go for the moderate grain of a 400 ISO film: Go all the way with a fast, high-grained film of 1000 or even 1600 ISO. If it's a sharp image you want, use a slow film of 25 to 100 ISO and a medium format camera. (ISO is a guide to the amount of light required to make a normal exposure on a particular film. The higher the ISO rating the less light the film requires.)

If you have limited time or resources, there are shortcuts to finding right films:

- **Call the manufacturer's representatives.** Call them if you have questions about new or existing products or if you've experienced unexpected or undesirable results when using their products (see page 89).

- **Talk to the pros.** Go to a professional photo store and ask the staffers for their recommendations. They will not only be able to give you the advantage of their own personal experiences with the products, but they will also have opinions and anecdotes from their other customers, many of whom are hard-hitting professionals.

PROFESSIONAL FILMS

There are several major differences between so-called professional films and amateur films. Amateur films have a long shelf life and do not require refrigeration. Professional films require refrigeration and have a shorter shelf life because they are manufactured to more exacting standards and uniformity of emulsions. Often, high-volume shooters purchase entire film lots to ensure exactly predictable results from job to job and store them in their freezers. Professional film is available in all formats and speeds and in print and chrome varieties.

Many of the roll films listed below are available in sheet film sizes 4 x 5, 5 x 7, 8 x 10 and 11 x 14.

COLOR PRINT FILMS

Most amateur and professional portrait photographers shoot 35mm and 70mm print film rather than chrome (slide) film. It's easier and less expensive to make enlargements, and the results are generally better. Color print film is available from 50 to 3200 ISO. Color balance, color saturation and exposure latitude vary significantly from type to type. My favorite color print films include:

Portra 160NC (Kodak)

- ISO 160
- Excellent exposure latitude: We've gotten great results from 2 stops underexposed to 2 stops over.
- Ideal for shooting kids; beautiful skin tones, realistic color reproduction, medium contrast and broad exposure latitude make this the most popular film of professional portrait photographers. I also recommend it to amateurs.

Superia Reala professional (Fuji)

- ISO 100
- Excellent exposure latitude, similar to Kodak's Portra 160NC.
- Excellent for shooting kids: Supersaturated color lends enhanced vibrancy.
- Special characteristic: Reala compensates for, or neutralizes, light with different color balances in all color hues. Where fluorescent light appears green and tungsten light yellow on other film, they all come out virtually correct—natural looking—on Reala.

Kodak Royal Gold 100 amateur

- ISO 100
- Excellent exposure latitude.
- Good film for general photography: Skin tones are warm; enlargements retain fine grain.
- Because this is an amateur film, it can be purchased at many one-hour photo stores and drugstores.

Kodak Royal Gold 400

- ISO 400
- Finest-grained 400 speed film I've found; supersaturated color.
- Amateur film can be purchased conveniently.

Max 800 (Kodak)

- ISO 800
- Nearly as fine-grained as Kodak Royal Gold 400, but slightly higher contrast.
- Good all-purpose, or universal, film for use when shooting simple snapshots or when you just don't know what lighting situations you'll encounter and you don't want to use electronic flash.

Super HG 1600 (Fuji)

- ISO 1600
- Good for shooting when you know you're going to have little available light.
- Surprisingly good contrast and color for such a high speed film.

COLOR CHROME FILM

The film most often used by commercial and stock photographers whose work is to be reproduced using color separation, rather than photographic processes, is 35mm chrome (also called slide or transparency film). I don't recommend chrome film for amateurs making portraits of children because general exposure latitude is much more limited than with print film, even taking into account the potential for adjusted processing at a professional lab. If you do shoot chrome film with the intention of making prints or enlargements, read about the two types of printing methods in chapter ten.

Ektachrome E100SW professional (Kodak)

- ISO 100
- This film replaces Velvia as my favorite fine-grain chrome film for photographing kids. It gives results similar to Velvia: supersaturated color, warm skin tones, fine grain. But at a true ISO 100, you gain 1 to 1½ exposure.

Fujichrome Provia professional and amateur (Fuji)

- ISO 400
- Fujichrome is my favorite 400 ISO chrome film for photographing kids. Good skin tones, contrast, detail and color saturation.

Fujichrome Provia 1600 amateur (Fuji)

- ISO 1600
- Use only for low light situations
- Special characteristics: intended for push processing, so can be shot at 3200 or even 6400 ISO.

Kodachrome professional and amateur (Kodak)

- ISO 25, 40, 64, 200
- Warmer skin tones than Ektachrome, little grain, very high color saturation.
- Special characteristics: Unlike other chrome films, which are developed using the E-6 process, Kodachrome must be developed using the K-14 process, which is available at only a few labs in the country.

BLACK-AND-WHITE FILM

Just as with direct color photography, there are many different film types. In general, black-and-white film has significantly lower exposure latitude than comparable speed color films, but some types, such as Tri-X pan professional (Kodak) and P3200 professional (Kodak), make up the difference with excellent results when push processed.

Tri-X Pan professional (Kodak)

- ISO 400
- Great exposure latitude, often used by photojournalists: a versatile film, fast enough for use in many lighting situations; fairly high grain, high contrast; good for push processing for a high-contrast, impressionistic look.

T-Max 100 professional (Kodak)

- ISO 100
- Can be adjusted in processing without harming overall quality, nearly grainless, fantastic detail and sharpness, the black-and-white film choice in studios.
- Special characteristics: I've never gotten good results machine processing this film. It should be hand processed, ideally using D76 chemistry in a ratio of 1:1. If you can't hand process, shoot T-Max 400 for machine processing with good results.

T-Max 400 professional (Kodak)

- ISO 400

- The same speed as Tri-X, but noticeably finer-grained; like T-Max 100, can be adjusted in processing without damaging quality. Unlike T-Max 100, this film can be machine processed with good results.

T-Max P3200 professional (Kodak)

- ISO 3200 (can also be shot at 6400)
- Fast film with fantastic exposure latitude and grain comparable to Tri-X that has been pushed 1½ stops; great for shooting in low light situations.
- Special characteristics: must be adjusted-processed by a professional lab whether shot at 3200 or 6400 ISO.

Black and White + Select (Kodak)

- ISO 400
- Relatively fine-grained, somewhat contrasty film.
- Special characteristics: designed to be processed using color chemistry, so it can be processed quickly, cheaply, conveniently and, most important, successfully at any color photo lab.

Technical Pan professional (Kodak)

- ISO 25
- Virtually grainless; high resolution; can give interesting, nearly white skin tone; great detail can be maintained even in high-contrast printing.

Don't fall into the trap of simply having a few rolls of ISO 400 amateur film lying around. This is what I like to keep in my freezer and/or camera bag:

- *Fuji Superia Reala 100* for situations when there's plenty of light, such as outdoors in full sun or with electronic flash.
- *Kodak Max 800* for moderate to low lighting situations, such as indoors when you want to avoid using electronic flash.
- *Kodak T-Max 100* for fine-grained black-and-white images of well-lit scenes.
- *Kodak T-Max 400* for reasonably fine-grained black-and-white images in moderate to low light.
- *Kodak P3200* for use in combination with push processing for highly grained images in low light.

Kodak Film Representative: 800/242-2424; Web site http://www.kodak.com

Agfa Film Representative: 201/440-2500; Web site http://www.agfanet.com

Fuji Film Representative: 800/743-3854; Web site http://www.fujifilm.com

Konica Film Representative: 800/283-0653; Web site http://www.konica.com

If a company representative isn't able to help you, check with your local lab.

FILM TO ALWAYS HAVE ON HAND

Quality, handline processing and hand-printing of this picture give it the beautiful white highlights, black blacks and detail throughout the tonal range, which is the sign of a successful black-and-white portrait.

Strobes; studio; Nikon 8008; Nikkor 35–105mm zoom AF lens; Kodak Plus-X 100 (b&w professional film).

If you're an amateur, you're probably used to using the one-hour photo lab for processing, enlargements and even purchasing your film. There's no doubt these places are convenient and serve a valuable purpose. But there are professional (also called commercial) labs that welcome the general public and can open up a whole new world of creative and technical control to you. The cost of processing 3½ x 5 or 4 x 6 prints, also called mini lab prints, will probably be more than at the one-hour places. But if you want to a custom enlargement or you have a negative that needs burning or dodging, a professional lab is the place to go. Let's take a look at the features of and differences in these three types of labs—one-hour, commercial and wholesale.

ONE-HOUR LABS

- *Processing* is of 35mm only. They are economical and fast. Usually only one type of chemistry is available.
- *Printing* is standard 3½ x 5 and 4 x 6 prints; glossy or matte. Usually only one brand of paper is available.
- *Enlargements* are machine prints in standard sizes to 20 x 30. Some places now offer custom cropping for an additional charge.
- *Processing and printing of black-and-white film* is available at most national chains. Usually only one type of chemistry and one type of glossy resin-coated paper are available.
- *Chrome services* include E-6 processing and mounting and either type "r" or type "c" prints. Some places will sell you the internegatives for type "c" prints. See page 96 for an explanation of "r" and "c" prints.
- *Other services and merchandise* at some national chains include copy stand work (photographic copies of flat artwork or photographs), in-store credit cards, credit on merchandise returns, professional and volume discounts, photo novelties such as Christmas ornaments and photo sculptures, ready-made frames, mats and photo cubes and photo greeting cards.

Pushing (overdeveloping) chrome film can give your shots
an impressionistic, softly grainy feel, as evidenced in this
collage of a young musician. Pushing also gives you the
option of shooting in very low light.

Overcast day; Nikon 8008; Nikkor 180/2.8 lens; Ektachrome
400 (professional film); shot 1 stop under the main meter read-
ing and push processed 3 stops.

COMMERCIAL/ PROFESSIONAL LABS

- *Processing* is available for all film types. Custom hand processing is available at an additional charge as are different chemistries, clip tests and adjusted processing.
- *Proofing* materials are standard 3½ x 5 and 4 x 6 glossy or matte finish machine prints, contact sheets, numbered proofs on medium and large format film and chromes, and enlarged (11 x 14 and 16 x 20) proof sheets.
- *Printing* is machine and custom and can include cropping, burning (making certain areas of a print darker) and dodging (making certain areas of a print lighter). Any size print is available to 46 x 96. Cibachrome prints and borderless, black-bordered or white-bordered prints are also available.
- *Complete black-and-white services* are available including prints made on fiberbase paper, sepia toning, selenium toning and composites.
- *Complete chrome services* are available including internegatives up to 8 x 10 for making prints, duplicating, type "r" and type "c" prints and poster-size transparencies.
- *Other services and merchandise* include retouching and airbrushing, color laser and bubble-jet copies, kodalith, pickup and delivery, overtime and rush service, store credit cards, professional and volume discounts, copy stand, masking, contrast control masking, retouching, digital imaging, and professional film and supplies.

WHOLESALE LABS

Wholesale labs cater to professional photographers and specialize in portraiture and wedding photography. You must be a professional photographer and have a tax-exempt number to patronize a wholesale lab.

- *Processing* is available for all film types. Adjusted processing may or may not be available.
- *Proofing materials* include numbered negatives and proofs, enlarged proofs, contact sheets, projection proofs.
- *Printing* is computer-analyzed machine prints (also called auto prints) and custom printing with cropping, burning and dodging. Other services include enlargements up to 20 x 30 and sometimes larger, studio name embossed on prints, economical portrait packages from the same or multiple negatives, burning in of edges and diffusion (softening the focus and contrast of the image).
- *Black-and-white services* include standard processing and printing on resin-coated, glossy paper. Black-and-white prints are available from Kodak VPS III color negatives.

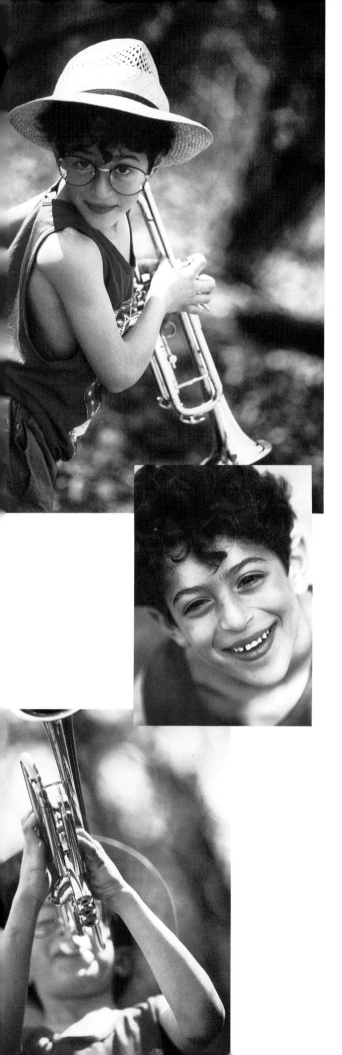

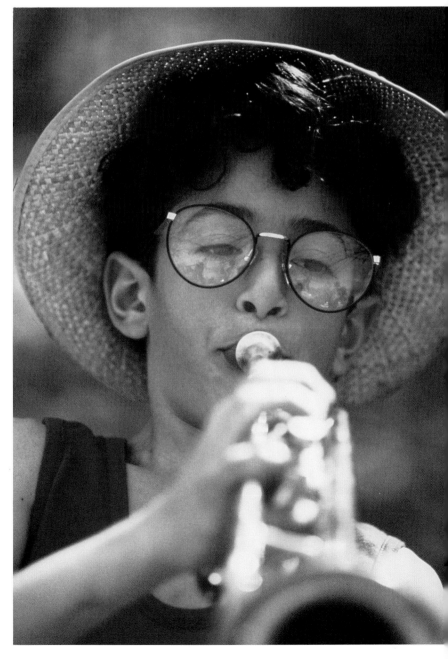

- Chrome service is E-6 processing (adjusted processing not always available), mounting, 35mm chromes from 35mm negatives (projection proofs), machine and custom type "c" prints, internegatives (may only be available in the same size as the original chrome).
- Other services and merchandise include lab credit cards, volume discounts, retouching and airbrushing, proof albums, professional film and supplies, photo folders, prints on canvas, and special mounting and finishing options.

GETTING THE MOST FROM YOUR LAB

To get the best product at the least expense from your lab:

- Shop around for the best quality and price. Prices can vary significantly, even among professional labs, but don't sacrifice quality for low cost.
- Ask questions. Develop an understanding of what your lab actually can do for you and what is simply impossible.
- Learn the lingo. For instance, format refers to the size, shape and proportion of film. 35mm film is small format; 70mm film is medium format; 4 x 5 and 8 x 10 sheet film is large format. Another example: *Reciprocity effect* is when a film is exposed for a longer or shorter time than it was designed for. Color balance is distorted and may need to be corrected.
- Learn what each lab does best and use it for its specialty. I use four different labs: one for black-and-white processing and proofing and type "r" prints from color chromes; one for color processing and proofing and color printing from print film; one for chrome processing and type "c" prints; and one for the rare occasions when I send out black-and-white custom printing.
- Most labs guarantee their work. There's not much you can do if your printing gets ruined (even the best labs mess up once in a while, and most only replace the destroyed film), but if you get unsatisfactory prints or enlargements, ask them to do it again. They should be happy to comply.

ADJUST PROCESSING TO SAVE SHOTS

The processing of chrome film and some black-and-white print films (such as Fuji Velvia 50 and Kodak Tri-X 400) can be adjusted to compensate for over- or underexposure. If you're uncertain about your exposure, you can bring your film to a professional lab and ask for a clip test. They will process only the first two or three shots on the roll for you to examine. Then the processing of the balance can be adjusted to make the final product darker or lighter, as necessary. *Pushing*, or overprocessing, the film brightens and lightens it, in some cases causing greater contrast, color saturation and higher grain. *Holding*, or underprocessing, darkens the

finished product, in some cases lowering contrast and muddying colors. While adjusting the processing, especially within the range of ¼ to 1 stop, can improve the results when film is exposed incorrectly, it cannot completely undo the damage. Overexposed film will still lose detail in the highlights, and underexposed film will still lose detail in the shadows. Some films that respond well to push processing are Velvia (pushing less than 1 stop won't damage the quality) and Kodak P3200. (See chapter nine for more details on these and other film types.)

Think of your negative or chrome as raw material, not as a finished product. There is no one correct way to print any given photo: Give the same negative to one hundred different people to print, and you'll wind up with one hundred different pictures. The more you understand about what's possible with color printing and the more explicit you make your requests, the better your color lab can please you.

PRINTING YOUR COLOR PICTURES

Contrast is critical, and balancing it can be tricky because what constitutes good or bad contrast is partly subjective. Too little contrast makes a print looks flat, lifeless, colorless and one-dimensional. Too much contrast makes colors look artificial, shadows block up (muddy up and lose detail), and highlights blow out (go too light with little or no detail). Make sure your color prints have white whites, black blacks and good detail in both highlights and shadows. Contrast can be adjusted somewhat in the color printing process, but not to the degree that it can be in black-and-white printing.

Color balance is critical, too. All color prints have yellow, magenta (a red) and cyan (a bluish green) in them. If your print looks too blue or too green (cool), it needs less cyan. If it appears too pink or purple, request less magenta, or less cyan and magenta. If it appears too yellow, it of course needs less yellow. Too much cyan, in addition to cooling the tone of a print, makes it more contrasty as well. Too much yellow lowers the contrast and muddies the blue tones.

Uniformly poor color balance in a negative or chrome film, such as the blue cast caused by shooting under an overcast sky, can be partly or even completely corrected in the printing process. Irregular areas of poor color, such as those caused by multiple light types, are not nearly as correctable.

Density refers to the darkness or lightness of a print. If you think the print is too light, you need to ask for more density; too dark, it needs less density. Prints made from negatives and chromes that are too dark or too light can be partially and sometimes completely corrected.

Use a proof, or 4 x 6 print, as a jumping-off place for your lab when request-

ing reprints. Mark cropping instructions right on the face of the proof. Indicate whether you want your enlargement to have the same contrast, color balance and density as the proof or whether you want it darker, lighter, warmer or cooler.

SPECIALTY PRINTING In addition to adjusting contrast, color balance and overall density, your print can be custom cropped (printing only a portion of the image), burned (darkening areas of a print), dodged (lightening areas of a print), vignetted (burning in the edges of the shot) and diffused (softening the focus and contrast).

Two types of prints can be made from chrome film. Type "r" prints are made directly from the original, positive image and are crisper and clearer than type "c." They are also less expensive but can be more contrasty and hold less detail. Many commercial printers discourage using type "r," and some simply don't offer it.

Type "c" prints are made from an internegative: a negative image that is made from the original, positive image. Because this process involves an extra step, or generation, the enlargements can appear slightly fuzzy. But the larger the internegative, the crisper the picture. Interneg sizes commonly made from 35mm chromes are 35mm, 6.7 and 4 x 5. For most enlargement sizes it's not necessary to make an internegative larger than 4 x 5.

Most one-hour photo stores offer either type "r" or type "c" (from 35mm internegatives), but usually not both. Ask which type your store uses.

PROCESSING BLACK-AND-WHITE PICTURES Black and white is considered by many to be the ultimate photographic portrait medium. With archival processing and professional framing, black-and-white photographs will survive from generation to generation. When it's used in photographing a child, I think the subject's personality, character and spirit are represented more truly and clearly than in color, which can distract from the subject.

Where to go for processing. Though the one-hour photo labs will take black-and-white processing, I don't recommend using them. They don't offer adjusted processing, they usually have only one type of chemistry, and they receive black-and-white film so infrequently that I can't believe their chemistry is always fresh.

Find at least two different professional processors. Shoot two short test rolls of your favorite film with exactly the same subject and lighting. Send one to each lab for processing, then have contact sheets printed at normal (#2) contrast. Look for noticeable differences in quality of grain, contrast and density.

I once assumed that professional labs all ran black-and-white film for processing in the chemistry recommended by the film manufacturer. I was wrong. I had

switched from one professional lab to another for processing and discovered that there was noticeably higher contrast and slightly more grain than before. Nothing about our shooting had changed. I finally called my new processor and learned that they were running my Kodak Plus-X Pan professional film in T-Max film chemistry.

How to recognize good black-and-white prints. To evaluate a black-and-white print, look for these qualities: The blacks should be solidly black, and the whites white. Look at the pupils—those are the two spots in every print that should be true black. Skin tones should be pleasing, not muddy. The face should appear softly contoured, not flat. There should be good detail in the complete tonal range.

Unlike direct color photography, which can often be successfully printed by machine, black-and-white machine prints are rarely of great quality. It requires a human touch and a discerning eye to achieve pleasing skin tones and overall contrast, and it's a rare negative that doesn't require some custom dodging or burning.

If possible, find a professional lab that specializes in custom black-and-white printing. Always ask for archival paper and processing to guarantee that, in fifty years, your children's children will be able to enjoy the portraits you make today.

Really good custom archival black-and-white printing is hard to find and costly. Consider setting up your own darkroom in your basement or extra bathroom. If you want to do your own black-and-white printing but aren't able to set up your own darkroom, look into these alternatives:

- Photographic equipment rental shops often also rent darkroom time; you supply your own chemistry.
- Universities and community education programs frequently offer adult extension courses in photography, which allow you access to their darkrooms. In situations like these, check the chemistry to see that it's fresh.
- Other photographers are sometimes willing to rent their darkrooms. Put a note on the bulletin board at your professional processing lab.

PHOTO RETOUCHING

Retouching is generally available only at professional and wholesale labs. They charge either by the head (subject) or by the hour, with a fifteen-minute minimum.

Retouching can be done digitally, on prints or on negatives to correct blemishes, wrinkles and shadows cast on the face, such as by eyeglasses. Some labs will only add density to an area on the negative, making it appear lighter in the print. Other labs may also offer retouching techniques that subtract density on certain areas of the negative, making it appear darker on the print. In addition, retouching can open eyes; remove red eye, moles and wrinkles; and replace missing teeth.

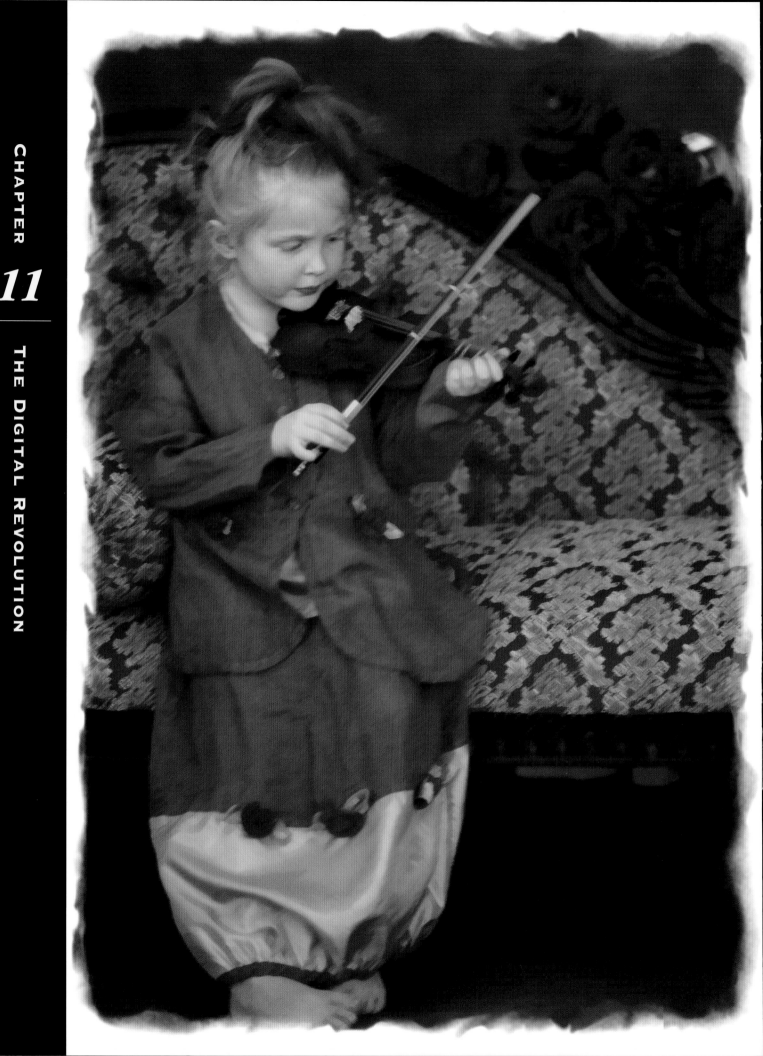

Though digital technology may make it seem easy for any-
one to create masterpieces, remember you still need a pro-
fessional photographer's know-how to create a beautiful,
original image, whether on film or digitally.

Available light; studio; Nikon N90s; Nikkor 180 AF lens; Kodak
E100SW; altered using Adobe Photoshop.

With digital imaging, any bozo with a computer can be a photographer. Or, *With dig-
ital imaging, anyone can create digital images, but they still need to have the same
skills that are used in traditional photography to make their images good.*

Digital imaging is an instrument of the devil. Or, *Digital imaging is a photogra-
pher's best friend.*

Which of the above statements are true? It depends on whom you ask. According
to my sources, film sales of all formats are flat. Many professional labs are facing dif-
ficult transitions now, deciding what resources and services to allot to digital imag-
ing and what to keep of traditional imaging. With both enlargers and digital printers
requiring an enormous amount of space, for some labs it's an either/or proposition—
either stick to traditional equipment and services or phase them out and go com-
pletely digital. I asked one lab rep if film is dead. "No," he said, "but it's breathing
funny."

Photographers I informally polled disagreed on how the digital revolution is
affecting their businesses. No one I spoke to had totally phased out film. The pro-
portion of digital imaging to traditional shooting varied from 20/80 to 50/50 to 80/20.
Some photographers seemed happy with their new digital options, while others dis-
liked the technology so much that it almost made them want to get out of the busi-
ness altogether.

And what about our friend Bozo? "He's not going to take any business away from
the real pros," says one portrait photographer. "Remember when computer graphics
programs became readily available on PCs? Then for a while everyone was a 'graph-
ic designer.' But PCs and design software have always been pretty affordable. With
commercial-grade digital systems ranging from $30,000 to $50,000, only really seri-
ous shooters are going to tool up."

Well, what if Bozo uses the new digital technology to make images of his own
kids and never comes in for professional shots again? Says the same photographer:
"The consumer-grade digital imaging just isn't great yet. And even if it were, it still
wouldn't make anybody a photographer. Instinct, lighting, technique, timing—that's
what makes a photographer."

A NEW AGE

Digital technology can be used to render portraits virtually indistinguishable from classic film-recorded images, such as this head shot . . .

Strobes; studio; Nikon N90s; Nikkor 38–135mm zoom lens; Kodak E100SW (professional film).

Or it can be used to create an entirely new, painterly effect.

Strobes; studio; Nikon N90s; Nikkor 38–135mm zoom lens; Kodak E100SW; altered using Adobe Photoshop.

The very first digital image I ever saw was a consumer-grade print on regular computer paper, and I wrote off the whole new technology based on that single image. I didn't get interested again until I started to wonder if there was a way to offer hand-painted-looking portraits with a fraction of the labor, at a fraction of the cost, digitally. I couldn't find anything that satisfied all my requirements, so I dropped the idea again. Finally, I found a way to offer my clients a new look in portraiture that is an archival, beautiful new medium in its own right. I use direct color chrome originals, scan to the computer, use Photoshop filters to "paint" various parts of the image for an impressionistic feel, and print on Arches cold press paper. Because it is still labor-intensive and the materials and printer are very expensive, it turned out to be a high-end product, as opposed to the affordable product I was searching for. But my clients have welcomed it with open arms, happy to have an alternative to my hand-painted, hand-printed portraits.

PROS AND CONS There are definite advantages and disadvantages for a professional children's portrait photographer switching to digital. The biggest drawback, of course, is the cost of acquiring a new system: $30,000 to $50,000 is a lot of sittings. And of course, you

need to learn how to use it. You have to know about TIFF files, JPEGS, megabytes, firewire cards, compression rates, Photoshop . . . you get the idea. On the plus side:

• No film, processing or printing costs: Who doesn't think that sounds great? With no costs until you actually make the prints, you can afford to "shoot" more images and give your clients more choices.

• Instant viewing: Common wisdom holds that the faster your clients can view and select their portraits, the higher their excitement level and, therefore, the more prints they'll buy. When you "shoot" digital, your clients can see the results instantly.

• No printed proofs: Since images can be viewed immediately on your computer, no proofs need be printed that might tempt the client to "just take them home and think about it," or ignore copyright law. And if your client wants her mother in Tallahassee to see the images, you can e-mail low-res versions and thereby increase your sales even more.

• Quick turnaround: You can put portrait orders into production the same day they're "shot." If your lab is online, you can send in your order with a click of your mouse. If you make your own prints, you fully control the length of time it takes to complete your orders. This could potentially increase your sales by giving you a longer Christmas rush. If you cut your normal turnaround time by two to three weeks, that's two to three weeks longer you have to take holiday orders.

• Storage: I never throw away any negatives, and I have thirty drawers full of neg files to prove it. With digital imaging, your "originals" on disk take up considerably less physical space.

• Less labor: With digital, you'll never have to cut, mask or otherwise handle a negative again.

• Easier (and better) retouching: I have retouched on negatives, on prints and on computer, and I'm here to tell you that it's easier, faster and better when done on computer.

So you like the sound of all these pros, and you're not afraid of the cons?

There are many different digital systems, and few of them are geared toward portrait photography; even fewer are geared toward childrens' portraiture. "The real impact of digital on portrait photography is still years away," one pro photo store rep told me. "Not until after they sop up all the commercial shooters' gravy will the industry concentrate on a really, truly portable system."

• Systems combining digital backs with traditional medium format cameras (most commonly Hasselblads) are cumbersome. While that's fine for commercial

**DIGITAL
SYSTEMS FOR
PROFESSIONALS**

photographers and portrait shooters who only shoot stationary subjects in traditional poses, it just won't work for the hand-holding, zooming, 35mm, shooting kids-on-the-fly types. Leaf Systems offers a digital back called Cantare, which has an optional location kit that allows the system to run off of a laptop, but it's still light-years away from the comfort of a traditional 35mm camera.

• Digital systems built into traditional camera bodies, such as the Nikon 660, are more portable. They capture the image at 6MB, which can be converted to and stored as an 18MB TIFF file. If this is all Greek to you, simply put in old-school terms, this means that the image quality is roughly equivalent to that of a medium format negative. But take note: The camera body alone—that's without lenses, bells or whistles—costs $23,000.

DOING IT ALL Ouch! That does sound expensive, but medium format quality in a small format camera—does this mean that digital really can do it all? My pro source tells me no, not exactly. "Can a digital system do 100 percent of what film can do? No. But it can do about ninety percent, and that's pretty good. We will still have to pull out a roll of film sometimes. On location, in low light or if you're shooting a lot of images away from a computer; would you rather buy one hundred rolls of Velvia or $10,000 worth of storage?"

MIX AND MATCH OK, the digital cameras currently available don't sound perfect for kid photographers. So how about shooting conventional film, scanning it, retouching and adjusting the image, and printing it out digitally? "I can see where you might think that's a good idea at first," says my pro source, "but digital media are a lot more expensive than regular prints. So you're still spending money on film, processing and proofing, and now you're paying more for your prints, plus a scan. Unless you have clients who are willing to pay more, this equation won't work."

WHERE THAT LEAVES US It seems the new technology could cost you money, but it could save you money, too. It's better at some things than traditional photography, not as good at others. But the bottom line? Digital technology is just another tool in your belt. Nothing more, nothing less. Making the transition from film to digital is expensive and it can be difficult, both emotionally and practically speaking. But then, most transitions are.

DO YOUR RESEARCH Only you can decide if it's worth the risk to make the change. To facilitate your decision making process, go to a professional photo store and try out a system. If

Here is an image shot on film as it appeared originally (above), and after being altered digitally (right). Though most of these changes can be made in-camera or by retouching, the new digital technology is a useful tool in creating artistic portraits.

Available light; studio; Nikon N90s; 38–135mm zoom; Kodak Portra 100.

you know a photographer who's already gone digital, pick his brain. Take a continuing education class on digital imaging. Use a variety of avenues to do your research because different sources will give you different perspectives. Talk both to people who are in love with the new technology and to those who don't like it.

If you still think you might want to go digital, then sit down and run your numbers. Figure out what a photo session costs you now and what it would cost using the new technology. Compare what you pay for an 8 x 10 now to what you would pay the new way. If you're planning on doing part of the printing yourself, don't forget that you can make mistakes with digital prints, just like in the darkroom. And digital media are considerably more expensive, so be sure to figure in an "oops margin."

If the numbers add up, go for it. If not, don't feel bad about sticking with your traditional setup. You can always revisit the new technology later, and the industry is changing rapidly. A camera, storage device or printer of the future may tip the scales in favor of a change.

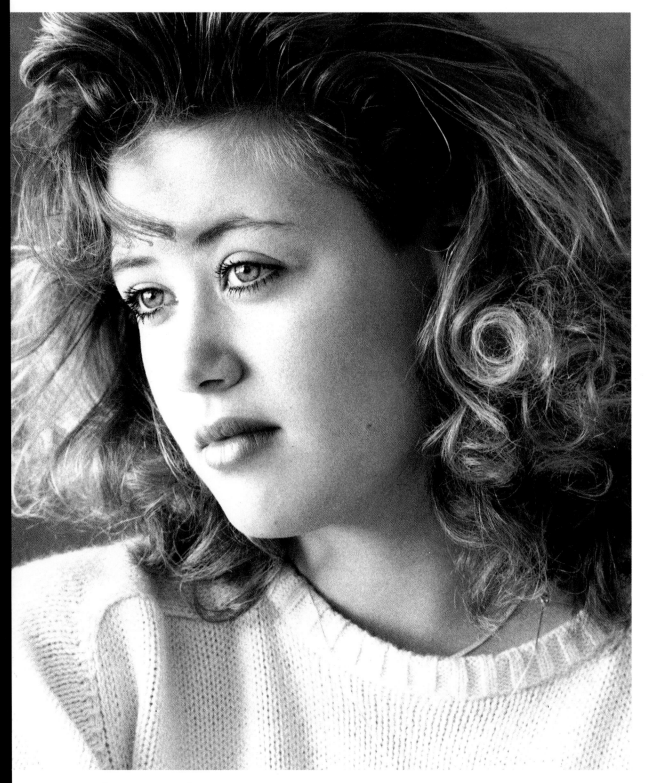

AVAILABLE LIGHT

This shot was made with available light from a northern window in the afternoon.

Equipment:
Nikon FE2 camera body, 35–105mm zoom lens, tripod, white fill card.

Materials:
Kodak Tri-X professional film.

Procedure:
• Position your subject approximately 5 feet from the window at a 45-degree angle; 5 feet in front of the camera; background or backdrop 12 feet behind your subject. Place a white fill card as close to the subject as possible (usually about 18 inches) on the side opposite the window, also at a 45-degree angle.

• Shoot at ISO 800, overexposing 2 stops from average meter reading.

• Push process 1½ stops.

• Print made on Kodak Polyfiber glossy paper, with 2½ contrast filter.

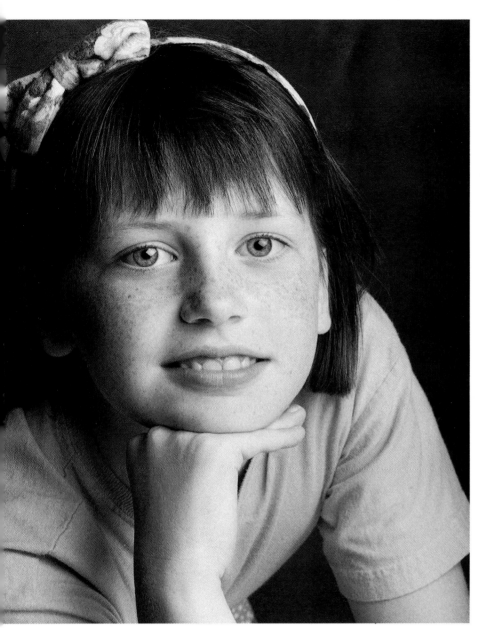

This shot was made in the studio using strobe light and reflectors. If you don't have strobes, you can substitute an electronic flash unit on an extension cord held away from the camera. Position your subject at least 5 feet away from a white wall so the wall will appear dark relative to the subject, approximating the backdrop in the illustration.

Equipment:

Nikon 8008, 35–105mm zoom, strobe unit, two light heads, two soft boxes, two white fill cards.

Materials:

Kodak Plus-X professional film, ISO 125.

Procedure:

• Position your subject, reflector and background the same as for the "Available Light" project, but use a strobe inside a soft box instead of window light.

• Expose film at 1½ stops over average meter reading.

• Process normally.

• Print on graded Agfa Portriga 118, matte finish, contrast 2.

Special Notes:

Even with the light hitting the subject at almost the same angle, an available light shot has a softer look; the strobe shot has a more sparkling appearance.

The photographic techniques in this chapter for you to re-create range from the very simple to the very difficult. One requires only open shade and a kid. On the other end of the spectrum, some require special papers, photo oils, and other materials and equipment. But the more complicated techniques don't necessarily yield more creative or beautiful results. In the hands of a skilled, intuitive photographer, the most straightforward techniques can make the most timeless, successful portraits.

In some cases I've listed alternative equipment and materials, so don't be shy about using substitutes if you don't have, for instance, a 180mm lens or if you want to put your own personal spin on the projects. Note, too, that guidelines for setting up your camera, subject and background relative to one another are only suggestions. The distance between the camera and the subject, and the subject and the background, will vary depending on focal length and personal preference for cropping.

Tackle whatever techniques appeal to your curiosity and ability level. And even if you're advanced enough to complete the difficult ones, don't shun the simple ones. They may help you create your most memorable pictures.

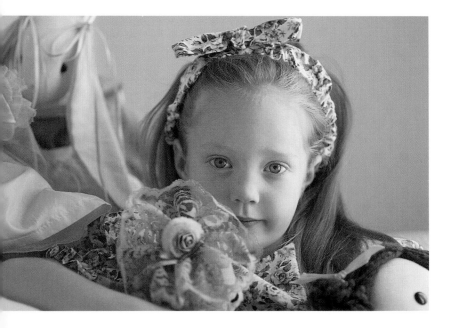

DIFFUSION SCREENS

This picture was made in the subject's bedroom amid her collection of dolls. The light came from the east-facing window late in the morning. There was just barely enough light to shoot at a thirtieth of a second at f2.8—a lighting situation in which most photographers would resort to electronic flash or a faster film. While flash would have made an acceptable picture, the fine grain and soft shadow play would have been lost, along with the beautiful mood of this shot.

Equipment:

Nikon 8008; 180mm lens; two 4 x 8 diffusion screens.

Materials:

Velvia chrome film, ASA 50.

Procedure:

• Position your subject about 5 feet from the window at a 90-degree angle; 10 feet in front of the camera; wall 2 feet behind the subject; diffusion screens on either side of the subject within approximately 2 feet.

• Shoot 1⅓ stops open from the through-the-lens or average spot meter reading.

• Process film normally.

Special Notes:

Because the picture was made during the morning with light from an east-facing window, the sun was pounding straight in, necessitating diffusion screens. Had the picture been made later in the day, the sun would have been in a different position, and the shot could have been made without the screens.

Alternative Equipment and Materials:

Equally satisfactory results can be achieved using print film, from which it is easier and less expensive to make enlarged prints. Kodak Portra or Fuji Reala film are good choices.

A SIMPLE SHOT

This shot was made on a sunny afternoon in open shade with no flash and no reflectors. It goes to prove that it doesn't take a lot of fancy equipment, exotic light or lots of styling and "stuff" to make a great picture: All you really need is a kid.

Equipment:

Nikon 8008; 180mm lens.

Materials:

Kodak Gold 100.

Procedure:

• Position yourself and your subject in any orientation within open shade.

• Shoot film on average meter reading.

• Process film normally.

Alternative Equipment and Materials:

You can substitute Kodak Portra or Fuji Reala for warmer color balance and greater exposure latitude.

SIMPLE HAND-COLORING

(Left) You don't have to make a big investment to explore hand-coloring techniques. This picture was made by photocopying a black-and-white photographic print and coloring the copy with colored markers, highlighter pens and colored pencils.

Equipment:
Photocopier.
Materials:
Black-and-white or color photograph; colored markers, highlighters, colored pencils.
Procedure:
• Make photocopies of original pictures.
• Color with markers, highlighters or pencils.

SERIOUS HAND-COLORING

(Right) If you're interested in getting more serious about hand-coloring photographs and you want to explore the use of oil paints and archival paper, here's my technique.

Equipment:
None.
Materials:
An 8 x 10 print on black-and-white, matte finish, fiberbase paper, printed at slightly lower contrast and slightly lighter than a normal black-and-white print (I use Agfa Multi-Contrast Classic MCC118 matte paper); Marshall photo oils and colored pencils; Prismacolor pencils; cotton balls and cotton swabs; kneaded rubber eraser.
Procedure:
• Lightly apply white and carmine photo oils mixed in equal parts on the background with cotton balls. Apply this color slightly into the figures, too, to create a smooth transition between background and the figures.
• Now remove the background color that you blended into the figures with a kneaded rubber eraser.
• Let the background dry about three days before applying the clothing colors. The colors of the girl's stripes are Marshall pencils orchid and sky blue; the sunglasses and bracelet are cadmium yellow and viridian green. The boy's coveralls are Prismacolor true blue, the buttons and hardware Prismacolor raw sienna; his shirt stripes are Prismacolor aquamarine. Skin tones are Marshall basic flesh mixed with a *tiny* bit of serge blue. Lips are the Marshall pencil called cheek; cheeks are Marshall oil paint color called cheek. Hair is Marshall oil color sepia extra strong.

GHOSTING

This technique uses a relatively long exposure during which tungsten light illuminates the backdrop and strobe light illuminates the subject. The longer tungsten exposure following the 1/250-second strobe blast allows you to convey movement by showing a "ghost" of your subject blurred against the background.

Equipment:

Small or medium format camera, medium length lens, tripod, tungsten light, strobe unit with one light head, soft box, umbrella or bare head reflector.

Materials:

Any relatively slow chrome or negative film.

Procedure:

• Position your subject at least 10 feet from your backdrop; position your light sources at whatever distance necessary to achieve the desired meter reading.

• The tungsten light on the backdrop should read on your meter about ½ stop darker than the strobe light on the subject.

• Shoot at a range of shutter speeds, from ⅛ to ⅟₆₀. The amount of blurring you get will vary depending on how fast the subject is moving and the shutter speed.

Special Notes:

Since it's impossible to predict your results, shoot many shots at each shutter speed. Because you'll be asking your subject to repeat her movement many times, it's important to work with an older child who's enthusiastic about helping to make the picture. If you have trouble getting the strobe and tungsten lights within ½ stop of one another because the strobes are too strong and the tungsten is too weak, try putting all your spare light heads onto your power box and firing them in the wrong direction to drain off power.

INDIRECT FLASH

This shot was made indoors with electronic flash bounced off a wall. Bouncing the flash creates a much softer, more natural look than direct flash.

Equipment:

Nikon 8008, 180 lens, #3 Tiffen diffuser for over-the-lens, electronic flash unit.

Materials:

Fujichrome 100 professional film. Tiffen #3 soft focus filter.

Procedure:

• Position your subject approximately 6 feet in front of the camera; background should be at least 6 feet away to avoid unwanted shadows; direct the flash at a wall that is at a 45- to 90-degree angle to your subject.

• Expose film ½ stop open from meter reading.

• Point camera-mounted flash at the wall at an angle to bounce onto the subject.

Special Notes:

It's important to position the flash in relation to the reflector, in this case the wall, in an optimal position for lighting the subject. Remember that the angle of incidence is equal to the angle of reflection. You may want to practice your aim using some test rolls before using this technique on an important subject.

Alternative Equipment and Materials:

Rather than a wall, a white reflector card can be substituted. Comparable print films are Kodak Portra and Fuji Reala.

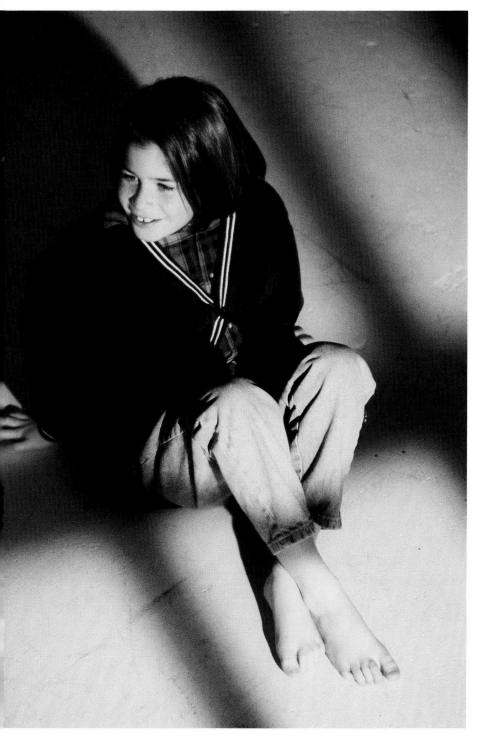

COOKIES

By using a hard, focused light and putting cutouts of various shapes (called cookies) in between the light source and the subject, you can cast shadow patterns that simulate naturally occurring patterns caused by light passing through windows, trees, reflecting off water and others. Cookies and mounts for tungsten lights can be purchased through theatrical supply companies, but you can make your own from cardboard that suit your needs more precisely and for practically no money. For this shot, we made a cookie that simulated window light with 2-inch x 4-foot strips of cardboard that we taped together while our models were changing clothes.

Equipment:
Nikon 8008, Nikkor 180/2.8 AF lens, tungsten theatrical spotlight, two white reflector cards, six 2-inch x 4-foot strips of cardboard, tape.

Materials:
Kodachrome 200 professional film.

Procedure:
• Position your subject approximately 12 feet from the light source, at a 45-degree angle from both the camera and the light source. Move your cookie back and forth. The closer the cookie is to the light source, the more diffused the shadow pattern will be; the closer the cookies is to the subject, the harder the shadow pattern will be.

• Expose film at 1 stop open from the average meter reading.

• Process film normally.

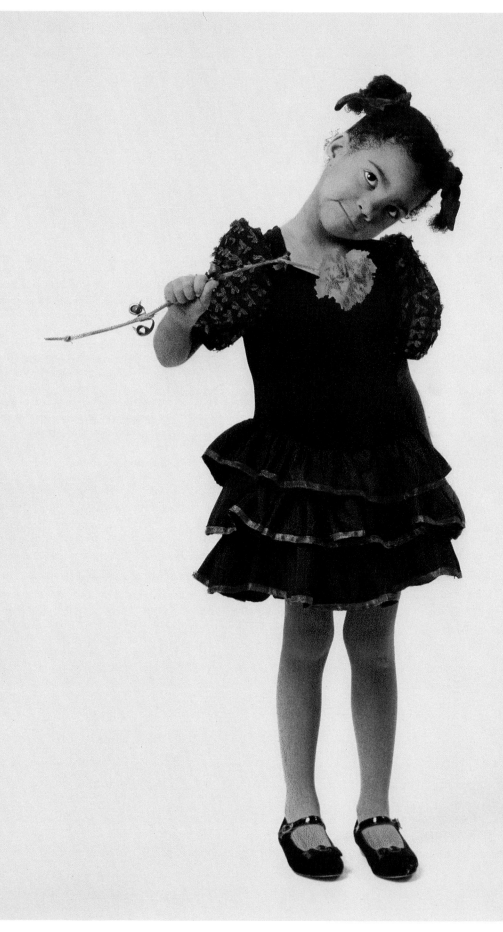

Asking the kids simple questions can elicit fun expressions. This little girl looks coy because I just asked her the name of her cat.

Strobe; studio; Nikon 8008; Nikkor 35–105mm zoom AF lens; Kodak Plus-X 100 (professional film); printed on Agfa Portriga 118 #2 contrast paper; hand-colored with artist's oils and colored pencils.

111

If you're a parent, you probably could have written this chapter yourself. You can skip forward to read about posing kids, or you might want to browse this section just to affirm your experience in working with kids.

There is a myth surrounding child photography that it is somehow difficult—sometimes even impossible—to work with kids. When I announced to my photographer friends my intentions of channeling my energies into child portraiture, I was met with sarcasm and astonishment. Comments such as, "Why would you want to do that? Kids will really make you sing for your supper!" abounded. And my friends were not the only ones who held this opinion. A nationally published photography trade publication ran an article in 1991 that purported to help photographers make portraits of "… your most challenging subjects," and went on to state, "… professional photographers dread working with youngsters … they [kids] care more about having fun than creating a great portrait."

Well, I'm here to tell you that if it isn't fun to make a great children's portrait (for both the photographer and the subject), then the portrait simply won't be great. And contrary to popular belief, children are perhaps the *easiest* subjects I've ever photographed. That's not to say that shooting kids isn't hard work—it is. But what worthwhile pursuit isn't?

Photographers run into trouble in working with children when they try to make them behave like little adults. If you let a kid be a kid, you can't help but get excellent results. I recall one client who came to me after being terribly disappointed with another photographer's work on her daughter's age two portrait. Trying to describe to me over the phone what she didn't like about it, she said, "She's a beautiful, vibrant little girl, but this picture is so … stiff. She looks like she's thirty years old. He made a sow's ear from a silk purse!"

I try to capture natural movements in my work—not just action, but those totally unself-conscious attitudes. The little girl playing with the fringe on her dress or playing with her hair; the little boy standing on the sides of his feet or twisting his sweater into knots; the kids playing air guitar or acting out exactly how the little engine that could made it up that steep hill. When people see my work for the first

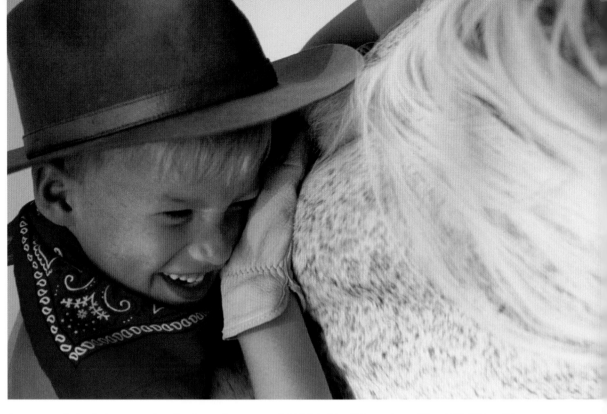

There is a myth that kids are somehow harder to photograph than adults. I find kids to be the easiest and most rewarding subjects. How many adults would have as much fun or look as natural in a portrait as these kids?

(Left) Sunlight; outdoors; Nikon N90s; Nikkor 180mm AF lens; Fuji Velvia 50.

(Middle) Ambient light; outdoors; Nikon 8008; Nikkor 180mm AF lens; Fuji Velvia 50

(Right) Strobes; studio; Nikon N90; Nikkor 38–135mm AF lens; Fuji Velvia 50

time, they often ask me, "How did you get them to do that?" My question to them is, "How would I get them to stop?"

There are no tricks to making children behave like children. There is an art, however, to earning a child's trust and helping her true personality and spirit shine through. And while children, like adults, are all individuals who respond to different things, there are certain constants, which I call Vik's Ten Commandments. If you learn them, you can take the myth of the difficult child subject and turn it into the magic of a great photograph.

1. Thou shalt not say "smile."

There are literally hundreds of facial muscles involved in a smile. It's nearly impossible for children or adults to give a natural smile on command. Instead of telling them to smile, give them a reason to. Make them really feel like smiling, and they will. One of the surest ways to get a child to smile at you is for you to smile at him.

2. Thou shalt not say "sit still."

No one likes to sit still, not even adults. I've never heard anyone say, "Oh goodie, I get to sit still for a five-hour version of *Hamlet*! And I can't wait for that ten-hour drive to Grandma's house next week! I love my desk job, because I get to sit still so much!" So it stands to reason that your most successful pictures will be of

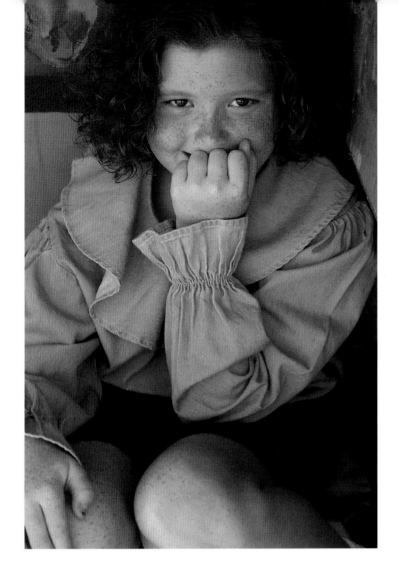

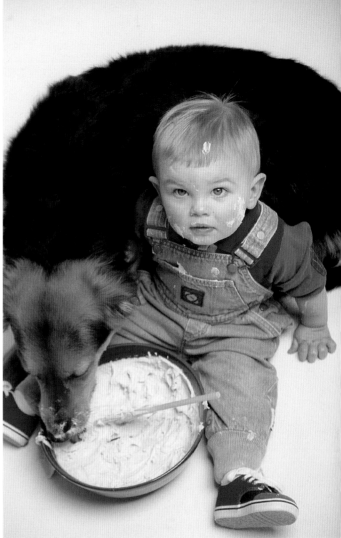

moving kids. If you must have a still subject—say for a head shot or a formal or group portrait—take frequent breaks to let the child move about in a constructive and controlled way. Don't let the kids tear around the studio. Join them in doing the hokey pokey or making funny faces or even playing catch. After a breather like this, position the subject and continue to shoot.

3. **Thou shalt not try to make a child act or look like an adult.**

As I mentioned above, a child is a young person, not a miniature adult. Kids have shorter attention spans and different interests and capabilities from adults. Respect kids for who and what they are.

4. **Thou shalt not ask of a child anything thou would not ask of an adult.**

At a very early age, children develop a sense of themselves, a sense of dignity and decorum and definite ideas about how they want to appear for the rest of the world. Just as you wouldn't insist an adult client wear a certain hat if she thinks it looks stupid, or jump, or go barefoot, neither should you insist a child do these things if it offends her sensibilities. You can ask, and if your suggestion is rebuffed, let it go. Sometimes after a while, the child will come back to your original suggestion and carry it out with glee as if she'd thought of it herself.

5. **Thou shalt have fun.**

If you are having fun, it's guaranteed that the child will, as well. You don't have

to be a giggling idiot, but if you enjoy your work, the kids will know, and they'll be much more willing to cooperate.

6. **Thou shalt offer encouragement.**

Kids need you to tell them when they're great. When children like and trust you, they naturally want to please you, and the more pleased you are, the happier the child. *You have the greatest smile! What a super leap! What a fantastic elephant imitation.* But be sincere—kids can smell a phony a mile away.

7. **Thou shalt be generous.**

To make successful pictures of children, you must be generous in every way: your time, your film, your energy, your focus and attention—your very self. I book my child portrait clients at least an hour apart. If there are three or more kids per family, I allow an hour and a half to two hours. I shoot an average of thirty-six to seventy-two shots per kid. I have actually had parents ask me to provide fewer proofs so there won't be so much to choose from. I go into every shooting day well rested and well exercised, knowing that I'm going to be jumping and laughing and expending just as much energy as my subject.

I have been told by other photographers that they couldn't possibly afford to spend the time I do with each client or shoot as much film, or they would lose money. While it's true I make very little, if any, profit on the sitting itself, my print sales more than compensate for this. If your fee structure is such that it forces you to do a big volume of kids in a short amount of time to turn a profit, you won't have a very good success ratio. Maybe it's time for a change.

8. **Thou shalt not intimidate.**

Just because you're bigger than a kid and it's your studio doesn't mean you can or should be the boss. Forcefulness and intimidation may get you your own way, but it won't get you a great picture. Look at the making of the photo as a collaboration between equals—you and the child. Besides, anybody who has ever tried to get a child to eat his vegetables or wear his sweater knows that intimidation rarely works at any age. From the time we are infants, we determine what goes in our mouths or on or bodies and whether or not we stand in front of the camera and smile.

9. **Thou shalt not ingratiate.**

By the same token, never be ingratiating. You're still forcing yourself on the child, just in a different way. Relax and take the child's lead. She'll let you know how much she wants to let you into her personal space and how quickly she can warm up to you. All you have to do is be there and be ready when she is. I have

I gave the boy on the left a small ball just before I shot and asked him to hide it from the camera. You can't see the ball, but his resulting mischievous expression makes this a great portrait.

Strobe; studio; Nikon 8008; Nikkor 35–105mm zoom AF lens; Kodak Plus-X 100 (professional film); printed on Agfa Portriga 118 #2 contrast paper; hand-colored with Marshall photo oils and colored pencils.

a friend who is accomplished at both jazz and flamenco dancing. She explained the different attitudes inherent in these areas of dance. The jazz dancer goes out into the audience, and the flamenco dancer draws the audience in to herself. I suggest you be mindful of the flamenco dancer's lesson, and let the child come to you.

10. **Thou shalt embrace (controlled) chaos.**

We have only three rules in our studio: don't do anything that might hurt you; don't do anything that might hurt someone else; and don't do anything that might hurt the equipment. There's always a lot of jumping, running, shouting, music and antics going on at our studio. Parents who require a large amount of law and order often leave our studio looking frazzled. But there is a method to our madness—if we didn't have the (controlled) chaos, we wouldn't get the same level of spontaneity and naturalness. I find it's easier to calm an excited child down a bit than to light a fire under a sedate one.

Of course there are limits. If you let kids literally run wild, they reach a point where you simply can't calm and focus them again. So we control the chaos by directing the activity and taking part in it. We do the bunny hop, the hokey pokey, animal imitations, play catch, and more, in between and sometimes even during shooting.

Memorize these ten commandments, and you will be on your way to working successfully and with a certain amount of ease in photographing children. Numbers five, six, seven and eight will be a big help to you during the most critical phase of your interaction with our child subjects—the first five minutes.

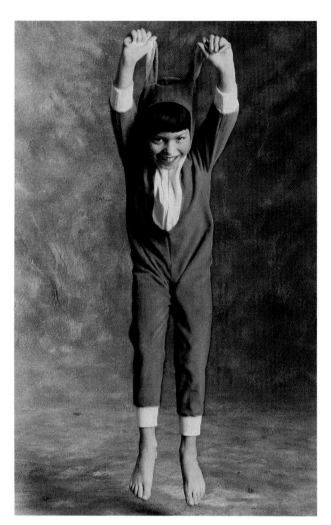
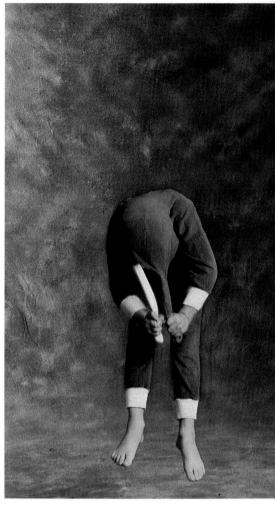

While of course all children are individuals and they all react to situations differently, there are certain behaviors one can predict with a certain amount of accuracy based on the child's age, placement within the family and age difference between her and her siblings.

Babies (three months to one year). The biggest problem with babies is that their inner clocks can change very quickly, so, if you book a shoot too far in advance, you're in danger of interfering with nap time, or lunch or a plain old crabby mood. Encourage the parents to reschedule if it looks like the appointment is going to fall at a bad time. It'll just be a waste of everyone's time and energy if the baby is tired, hungry, cutting a tooth or not feeling well.

Toddlers (one to three years). Toddlers can be unpredictable, too, because they are at an age when they're testing their boundaries, asserting their will, and discovering who they are. They are also highly mobile, and they like to move fast. Their moods are mercurial, and tears can be turned on and off like a faucet. The good news is that they almost never stay in a bad temper for long. The bad news is that their attention span is exactly one nanosecond. So allow plenty of time for the shoot to accommodate mood shifts, refreshment and play breaks. Find ways to shoot them while they're moving and playing rather than trying to get them to sit. One method I've found useful is to set the child down at the far back corner of the backdrop and have his mother call to him from the front opposite corner. The child

Approach the photo session as playtime, and you'll be rewarded with energetic, happy subjects like this one—and you'll have fun, too!

Strobe; Nikon 8008; Nikkor 35–105mm zoom AF lens; Kodak Plus-X 100 (professional film); printed on Agfa Portriga 118 #2 contrast paper; sepia toned and hand-colored with Marshall photo oils and colored pencils.

will run to his mother, usually laughing and smiling all the way, and I shoot when he's in the center of the drop.

Young children (three to five years). This age group is a little quieter than the toddler group. They are old enough to reason with, and they usually want to please you. Their attention spans are a bit longer, and they start to have wild senses of humor.

Children (six to nine years). At this age you may experience the opposite problem from that of toddlers—excessive cooperation. You'll meet good little girls and boys who sit still and smile a little camera smile and do exactly as they are asked. You need to loosen them up and get them to forget themselves. It can work wonders to ask kids to teach you something: I've learned baseball pitches, knot tying, dog training, and all the names of the characters in *The Little Mermaid* from my six- to nine-year-old friends.

Preteens (nine to twelve years). At this age kids can be charmingly awkward. They're part adult, part child, hauling their stuffed bear to the studio but also careful not to seem "babyish" or immature. Respect their sense of decorum, but don't lose your own sense of playfulness. Be open and accepting of both the child and the adult parts of them, but gently discourage any attempts at "cheesecake" or overly grown-up poses.

Teenagers (thirteen to nineteen years). Teenagers need a lot of reassurance and they embarrass easily. Shower them with genuine compliments and encouragement—not just relating to their appearance, but to all their interests and abilities. Marvel at their athleticism, intelligence, hobbies and anything they'll share with you.

Only, oldest, middle and youngest children. Only children tend to be confident and gregarious. Oldest children try to be helpful—sometimes too helpful, as in overly controlling their younger siblings. Middle kids often need a little extra attention to shine. Youngest children are sometimes a little lazy, being used to having older siblings do things for them.

The new baby. Sometimes when there's a new baby in the family, older siblings try to get extra attention by regressing to babylike behavior. If this happens, ignore the age-inappropriate behavior and ask the older child to help you meter the light, choose props, or hand you film. They'll get a kick out of getting attention for being big and capable while baby gets attention for being small.

Blended families. Frequently, siblings from different families of origin are spread apart in age, and this can make for some really fun pictures, with the

younger ones crawling on and being tossed into the air by the older ones. In the studio, at least, blended families don't seem to have any more discord or to be any less happy than any other families.

GETTING OFF TO A GOOD START

The first five minutes you spend with the child will sometimes affect the entire shoot. To get off to a good start, introduce yourself, greet the child and make contact with him in a noninvasive way. Take the child's lead as to what kind of contact will be appropriate—some kids are immediately familiar, and they'll welcome you to kneel down at their level, make eye contact, shake their hands and chat. But for some kids even this might feel too threatening. You'll have to let your intuition guide you. If you fault in one direction, let it be toward aloofness. Show a mild, genuine interest in the child, but don't be forced, falsely jolly or overly familiar.

Let the child know what to expect. Show him around the studio, show him the camera and where he'll be photographed and tell him what you expect of him. Tell him you're going to play and have fun. Ask him a question to which he must answer yes. "Do you like juice? So do I. Apple is my favorite. Do you like to jump and play? So do I. And that's what we're going to do today." Ask him if there's anything in particular he'd like to do in the picture—frequently he'll already have a few ideas, and they'll probably be good ones. Agree on a few things before you start—that you'll do some baseball poses, some jumping shots, even one with a funny face or with his tongue sticking out. Use the first five minutes as a getting-to-know-you period.

PLAY AND TALK

After the first five minutes, the two most important words for a child photographer to remember are *play* and *talk*. A child's job is learning about her world, and she learns through play. When you play with her, you're helping her do her job.

Talking with children is the surest way to help them relax in front of the camera. Ask them questions about neighborhood kids, pets, school, hobbies, food—anything that interests them. Do some research: find out about the latest video games; go to kids' movies; watch kids' TV. But also be careful—some parents don't allow their kids to watch cartoons they consider violent or to eat junk food. It's a good idea to find out in advance whether the child has ever eaten at McDonald's and if Winnie the Pooh is a better topic of conversation than rock music.

I almost always find out about some of the child's interests from the parents when they book their photo shoot. Once I was in the middle of a delightful portrait session with a seven-year-old boy when I started to talk about the new hockey stick he'd gotten for his birthday and about the angel fish in his aquarium.

Use kids' names when you're directing them during a shoot. This is especially important when you're working with a group of three or more. Just saying, for instance, "Put your arm around your sister," may not attract the child's attention at all. But saying, "Ben, put your arm around Sarah," always gets results. This pyramid shot of four siblings could have quickly deteriorated into total chaos if I hadn't been able to direct all the kids by their names.

Strobe; studio; Nikon 8008; Nikkor 35–105mm zoom AF lens; Kodak Plus-X 100 (professional film); printed on Agfa Portriga 118 #2 contrast paper; hand-colored with artist's oils and colored pencils.

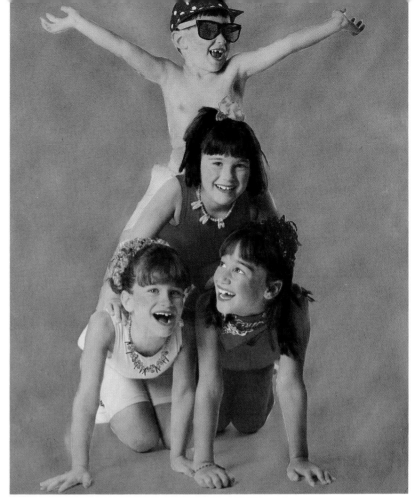

Suddenly he looked ashen and refused to cooperate. Finally he blurted, "How do you know all this stuff about me?" After I explained that his mother had told me about him, he was fine, but for a second there he feared I was some sort of omniscient oracle. Now I always precede any statement of knowledge about the child with, "Your mom tells me . . ."

When I first started working with kids, I asked around for ideas from other photographers, parents, social workers, day care workers and others on how to amuse and engage them. My queries were always met with vagueness. So when I decided to write this book, I vowed to offer concrete ways to interact that would help the photographer create expressive, natural pictures. Beyond simply talking and playing with kids, there are no magic tricks. But there are specific ways to talk and play that I've found encourage many kids to respond with genuine enthusiasm.

Storytelling. Some kids who are inhibited physically and don't want to jump or dance for the camera will open up and become unbelievably animated if you ask them to tell you a story, especially if you make one up together.

Catch. Catch is perhaps one of the best games in the world, enjoyed by children and adults. It not only relaxes your subjects and encourages dialogue, it also is one way of forging a connection. We play catch with kids, not only before and after the shoot, but during, too. My kid wrangler stands off camera and gets a good volley going with the child. Meanwhile, I'm getting some great pictures of the child holding out his hands to receive the ball, giggling, catching and winding up for the throw. Then I add an element to the game, saying, "Now after you throw the ball,

look at the camera and jump! Now after you throw the ball, look at the camera and clap your hands!"

I've got your nose. Some kids really get a kick out of the old grandpa trick of grabbing at the nose, sticking your thumb between your fingers and saying, "I've got your nose!" If you do this, be gentle, and always be ready to say, "Oh, it's okay, I don't really have your nose, see?" because some kids will believe you. You must admit, having a stranger walk off with your nose is a terrifying thought. Kids seem to have the most fun in getting your nose rather than you getting their noses. They may grab your nose repeatedly. Be sure to pat your face and act surprised every time.

High fives and secret handshakes. Another way to form a connection with a child is to get him to give you a high five or teach him a secret handshake. It's another way of using play to establish common ground. The sillier the secret handshake, the better. Pinky wiggling, elbow bumping, and arm flapping are all excellent components. There's also the old game of "Gimme five! Up high, down low . . . too slow!" in which you ask the child to slap your hand and then pull it away at the last second. This is also something that delights them to "trick" you back, again and again.

Reverse psychology. Sometimes if a child is being contrary, reverse psychology can work wonders. One four-year-old boy refused to stand on the seamless paper or to smile, instead stalking around the studio with a huge frown on his face. His quick-thinking father took off his own shoes and said, "Okay, guy, these are my shoes. Don't you dare put on my shoes." The boy immediately got a huge grin and made a beeline for his dad's shoes. "Oh no! Don't wear my shoes, and don't go onto the smiley face in them!" Dad cried in mock horror. Of course, the boy went right to his place on the seamless, wearing the shoes. "Oh my gosh! Get off of there right now! And whatever you do, don't smile!" cried the father. The boy giggled delightedly into the camera, and we got some great shots.

Peek-a-boo. Peek-a-boo can be lots of fun and can sometimes salvage a desperate situation. Ask the parent to put a hat, blanket, towel or other fabric over the child's head. Then say, "Gee, where did Dottie go? I don't see her." You'll probably hear giggling emanating from under the cover. The child will pull off the blanket and say, "Her I am!" "Wow, there she is. Where did you go?" The child will very likely put the cover back over her head and wait for more inquiries as to her whereabouts. Or have the parent hide behind the photographer and say, "Where's your mommy?" Then have Mommy pop out and then disappear again.

The penny press. If you're shooting a barefoot baby or toddler who won't stay within camera range or who simply isn't happy or is bored, you can sometimes elic-

it a smile or an interesting look by pressing an ordinary penny against the bottom of his foot. The penny will stick there for an instant, long enough for you to get out of the frame; then when it falls off, he'll bend over and pick it up, examine it, and eventually look into the camera.

Making funny faces. With small babies, making funny faces is one of the most natural and successful ways to connect. In my case, making funny faces is instinctive. If it's not for you, then practice in the mirror until you've built up a repertoire—it will be well worth the time.

Squeaky toys, rattles and noisemakers. Sometimes very young babies are too awed by new surroundings to focus on you or Mom or anything in the general direction of the camera. In these instances, when funny faces and dolls and puppets fail, I will use a squeaky toy or a rattle to get the baby to look toward the camera and smile.

Framing your requests. Sometimes your attitude in asking the child's cooperation makes the difference between success and failure. Instead of saying, "Susie, will you hold these flowers?" say, "Look, we get to play with these flowers now! Aren't they pretty? Do they smell good? How would you like to hold them?"

Kids do have definite ideas about what they do and don't want, but these ideas can change from moment to moment and situation to situation. Frequently they'll pick up on your attitude or their parents' attitudes when deciding what is or isn't fun. I recall one little girl who looked confused when I asked her what she wanted to wear in her picture. Finally she touched one dress and said, "Mommy, do I like wearing this?"

Narrow the field. It's important to give kids some control and some choices at the photo shoot, but too many choices can be overwhelming. So narrow the options—instead of showing the child a pile of clothes and asking her to pick an outfit, show her two dresses and say, "Do you want to wear the pink one or the blue one?" Likewise with props, toys and poses. "Do you want to hold the bear or the fire truck?" Do you want to jump or twirl?"

If mom doesn't work, try dad. Kids can be rather capricious about who they want to cooperate with at any given moment. More than a few two-year-olds have refused to wear hats or hold flowers proffered by their mom, but will gladly accept them from me. Or they won't wear a bow tied by me, but will wear one tied by mom or dad. So don't give up if one person fails to inspire cooperation. Try another—and another, until all the options are exhausted.

Bargaining. Sometimes bargaining works, and sometimes it doesn't. Unbelievably precocious twenty-six-month-old Ronnie, who spoke in complete

Bear in mind that the clothes kids wear affect the mood
they project, their movement and expression. Compare
these shots of a two-year-old girl, the first in coveralls, and
the second in a dress. Though made within ten minutes of
each other, notice the different moods of each shot.

Strobe; studio; Nikon 8008; Nikkor 35–105mm zoom AF lens.
Kodak Plus-X 100 (professional film); printed on Agfa Portriga
118 #2 contrast paper; hand-colored with Marshall photo oils
and colored pencils. Note that the shot on the right received
the same treatment as the shot on the left, but was sepia-toned
before coloring.

sentences, didn't want to wear her flip-up sunglasses. "Look, I have flip-ups, too!
I'll wear mine if you wear yours," I said. Reluctantly she nodded. When I put mine
on and she still wouldn't pick hers up off the floor, I said, "You said you'd wear
yours if I wear mine." "No!" "But we made a deal." "Then take yours off," she said.
Her logic was indisputable.

Frequently a little bargaining can go a long way. "Three more in the glasses and
then you can hold your bear for some," usually evolves into ten or twenty shots as
the child has fun and forgets to count.

Bribes and rewards. Some kids will do anything for a Barbie doll or a
McDonald's hamburger. While the offer of bribes can be an effective way to elicit
cooperation, I never use it. If the parents want to offer a bribe or reward, that's fine,
but I leave it up to them. As a photographer, I have such a brief amount of time to
spend with each child that I feel it changes the relationship if I offer a payoff at the
end of the session—it implies somehow that the photo shoot is something to be tol-
erated rather than something that can be a reward in and of itself.

Mirroring. I discovered mirroring by accident when working with a five-year-
old girl. She obviously wanted to cooperate, but stood in a strangely adult, con-
templative pose and wouldn't move when I asked her to jump. "Come on, let's
jump like a bunny," I said, but she just stood with her hand on her chin and her
legs crossed. Suddenly it occurred to me that she was standing in exactly the same
pose I was. So I broke the pose, and when I jumped, she jumped—I twirled, she
twirled. You can encourage the child to mirror your movements by subtly mirror-
ing hers.

Secrets and secret words. Even the most uncooperative kids can't resist a
secret. Sometimes if a child is restless, I whisper a secret word or phrase to him and
tell him to say it into the camera when I count to three. I do this ten or more times
in a row, changing the word each time. "Stinky feet" and "fuzzy fishies" are good for
giggles. Giving small kids words that are just a little challenging to say can stimulate
and amuse them—three-year-olds love to try to say "supercalafragilisticexpealido-
tious" and "antidisestablishmentarianism." Lizard pizza and boiled frogs work great,
too.

If we're shooting siblings together, I'll whisper a secret to one and have him whis-
per it to the other. While you sometimes get only a partial view of the whisperer's face,
the listener usually looks right into the camera, and this can result in an excellent shot.

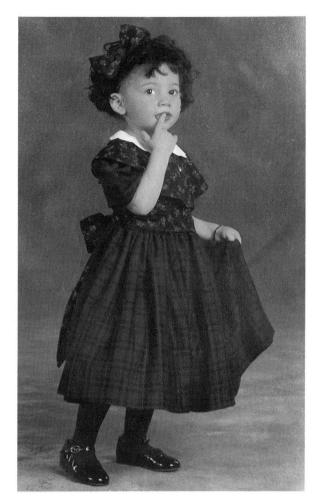

Shouting. Kids love to shout, and they aren't allowed to do it very often. Especially when shooting a group of two or more, I ask them what their favorite food is and then tell them to shout it out as loudly as they can. "What? I can't hear you," I shout back. We keep escalating, getting louder and louder, and the result is that in between shouts we get some really natural smiles.

Humor. I am convinced that kids have a sick sense of humor. But you don't have to resort to jokes involving bodily functions to get their attention. Ask them to tell you a joke—we all, adults included, laugh the hardest at our own jokes. I usually tell kids I need help coming up with jokes to tell other kids and ask them if they have any that might work. They usually take this request for help very seriously, and we can get a good shot of the child pondering his stock of jokes, followed by a big grin as he decides which one to tell. If you tell him a joke, speak a bit softly so he has to lean forward a little and concentrate to hear you.

I also sometimes resort to sight gags—a clown nose and Groucho glasses with a fake nose to elicit a giggle. Be careful not to try these with children who are too young, though, or you may have the opposite effect.

Hitting yourself on the head with a rubber hammer can be good for a few yucks, especially if it squeaks.

Holding or balancing almost anything on your head is good for at least one good response shot. This is especially useful when I'm trying to talk a child out of holding a beloved object because it's too large and distracting or it's appeared in

enough pictures. I just say, "Your teddy bear is going to help me take your picture now," and then I put teddy on my head. Once that gets a chuckle, turn teddy upside down. Plead ignorance. "What's teddy doing up there now?" ask them. From there teddy might try to thump or eat my head. It's hard to master puppeteering and shooting simultaneously, but if you don't have a partner or an assistant, it's well worth the practice.

Instead of asking kids to say cheese, I ask them to say something silly like, "It's not easy being cheesy," or, "Don't have a cow, man!" Sometimes even just the thought of saying one of these lines breaks them up and I get a good shot before they even say it.

Asking for help. Kids naturally want to please you, so if you invent ways in which they can help you, it makes the photo shoot more fun for them. I ask the kids to help by pushing the button on the light meter, watching or soothing younger siblings and thinking up new, exciting games to play in front to the camera. Helping you out gives the child a chance to feel important and to feel that he has some control over the session.



HOW TO ASSUAGE FEARS — Sometimes a child's first reaction to the photo studio is fear. Don't just assume you know what the child is afraid of—different kids may have very different fears. Ask what's scary. If the child isn't sure or isn't old enough to verbalize it, let him pop the flash, look through the lens, see his mom or dad go first and play with you on the backdrop for a while. Sometimes just discussing it helps.

Katie, a little two-year-old, came into our studio eager to have her picture taken (Mom had been pumping her up all week, telling her how much fun they would have and telling her to say, "photographer"), but when she got in front to the camera, she broke into tears with genuine fear. Thinking it would help if she left, Mom went for a walk in the hall while I asked Katie what was wrong.

"Are you scared?" A tearful nod.

"What part is scary?" A shrug.

"Is it the flashing lights?" No.

"Is it the camera?" No.

"Is it me?" To this, Katie looked at me sideways as if I were a bit slow and said, "No-o-o, silly."

"Is it being all by yourself on that big backdrop with nobody near you?" Pause. Voilà! Once we knew what the problem was, Mom came back into the studio and we spent some time playing sword fight with orchid branches on the backdrop.

Gradually I moved out of the frame, then Mom did, and soon Katie was happily dancing, running and jumping for the camera. She even did her specialty—a little clenched jaw expression she called "hyperface."

While Katie was afraid of the isolation she felt all alone in the middle of the shooting bay, other children might be afraid of other things. A little exploration into the offending objects usually is all that's needed. If the child is afraid of the flashing strobes, I let her push the button and fire them off a few times. If she's afraid of the camera, I let her look through the lens at her mom or even take a few shots of Mom herself.

Frequently a child's fear of a new activity can be diminished if she sees a familiar person doing it first. If the child doesn't want her picture taken, I'll take a few shots of the parents. I usually say, "Okay, Betsy, you stand over here by me and we're going to take some pictures of your mom and dad. Just your mom and dad alone, not with you, okay?" After about five seconds, most kids run to join their parents in front of the camera.

Even when you can't figure out exactly what the problem is, a play session on the backdrop, with or without Mom, is the best cure.

Given enough time and interaction, even children who come in hiding behind Mom's skirt will begin to enjoy the photo session and wind up saying, "Mom who?" It's natural for kids to have fun. But it's also natural for kids to experience some fear when faced with new and unfamiliar places and people. That fear will go away with some patience.

Some parents like to visit the studio a week or so before their scheduled shoot to introduce the child to the surroundings and to me and watch another family shoot. While I welcome these preshoot visits, I don't find that they make any difference in the ultimate comfort of the child or the success of the photo session. These visits seem to be more valuable to the parent to become acquainted with my personal style or to get ideas for what to bring along to their shoot.

USING MUSIC

When we shoot, we almost always have a little music playing in the background. We generally keep it low so we don't have to strain to hear or be heard, unless the child requests it be turned up. We keep a collection of tapes that appeal to adults and older kids, as well as children's artists (Raffi seems to be the most popular).

OFFERING SNACKS

It's good to have some individual servings of a healthy, not-so-messy snack and some juice at your photo sessions. Keep the snacks out of sight and only offer them

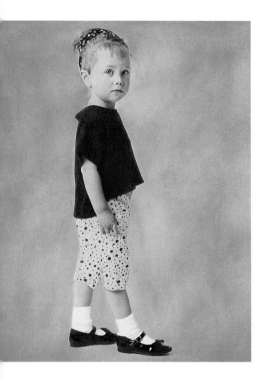 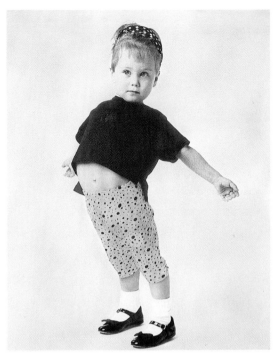 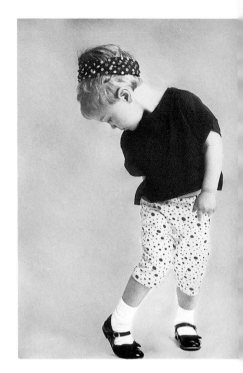

if the child's attention is growing short or he needs a break or needs to be soothed. I stress individual portions because they help you limit the length of the snack break and the quantities consumed. I made the mistake of using jumbo packs of cookies and crackers in the fledgling months of KidCapers and watched the clock tick as more than one small child refused to return to the photo session until he'd consumed twice his body weight in treats. With individual portions you can say "All gone"—something even the youngest child understands. Raisins and bite-sized animal crackers are good selections. Avoid anything gooey, crumbly, chocolate or grape, or the child will probably wind up wearing most of it home.

THE WINDOW OF OPPORTUNITY The window of opportunity for great shots—the time when the studio and the photo session are comfortable enough so that the child isn't afraid, but new and interesting enough to amuse her—can seem pretty short sometimes. So try not to run behind schedule so you have to keep a family waiting. If you do, you'll probably be met with a bored, uncooperative kid and comments from the parents such as, "Well, she was smiling when we got here."

Of course, kids—like all people—are individuals, and it's tough to generalize. Taken alone, none of these activities is a "sure thing." But they'll give you a place to begin, and as you gain more and more experience in working with kids, you'll find ways to adapt based on your own personality and sensibilities. If you're at a loss, remember that you can always schedule a reshoot. But if you take the child's lead, treat her with respect and maintain a playful spirit, you can't help but succeed.

(Left) Unlike babies, toddlers have a great range of movement. The challenge with this age group becomes getting them to stay on the backdrop.

Strobe; studio; Nikon 8008; Nikkor 35–105mm zoom AF lens; Kodak Plus-X 100 (professional film); printed on Agfa Portriga 118 #2 contrast paper; hand-colored with artist's oils and colored pencils.

(Right) Teenagers follow instruction easily and with encouragement make delightful subjects.

Strobe; studio; Nikon 8008; Nikkor 35–105mm zoom AF lens; Kodak Plus-X 100 (professional film); printed on Agfa Portriga 118 #2 contrast paper; hand-colored with artist's oils and colored pencils.

(Left) Different childhood ages provide joys and challenges for the photographer. For example, if you catch a baby (up to six months) after a nap and a meal, she'll be a perfect subject, though she doesn't have much range of motion at that age.

Strobe; studio; Nikon 8008; Nikkor 35–105mm zoom AF lens; Kodak Plus-X 100 (professional film); printed on Agfa Portriga 118 #2 contrast paper; hand-colored with artist's oils and colored pencils.

Capturing the best expressions, attitudes and gestures is not a matter of "how," but "when." Rather than trying to contrive a pose, be ready to shoot when a great one comes naturally.

Strobes; studio; Nikon 8008; Nikkor 35–105mm zoom AF lens; Fuji Velvia 50.

When people see my work for the first time, they often ask me, "How did you get the children to 'pose' that way? They look so natural."

My response is that we didn't "get" them to do anything, and furthermore, there is no such thing as a pose. To pose implies stillness, and from the time we are born we are in perpetual motion. In my experience, the best photos are made, not when the child is "posed," or still, but when he is in movement from one attitude to another. It is not necessarily the moment of action, but the rising or descending from action that often makes the best picture.

My approach to shooting children is to simply capture the great expressions as they go by. It's much less a matter of "how" than of "when."

Genuine expressions of abandon are absolutely fleeting. Likewise, the right moment to capture them is when the child is in midair jumping; with her hair, arms and legs just so in the middle of twirling; or arms akimbo, dancing. No one can tell you when that perfect $\frac{1}{250}$ of a second will occur, and you can't *know* when—you have to *feel* when. If you try to anticipate the action, you'll shoot too soon; and if you wait until you see something you like, it will be gone by the time you press the button. So you have to learn to rely on your instinct and feelings. This may be difficult at first, when we seem to be taught in this culture to value thinking over feeling, judgment over intuition. You may be out of practice in trusting your instincts. But don't give up. Like so many other things, a cliché that we all learned in our own childhoods—practice makes perfect—proves true.

To snatch those in-between moments, I sometimes ask a child to twirl around and then look into the camera. Shot at the moment she's about to twirl or when she's recovering her orientation afterward, you see no evidence of the action of twirling at all, but you have a natural moment.

Often I ask a child to point her toe, look at her toe, then look into the camera. Putting together several simple motions can relax the child and help her to move naturally. I may shoot when she begins the action, in the middle or after she's through, depending on how I feel.

CAPTURING
PEAK ACTION
OR EXPRESSION

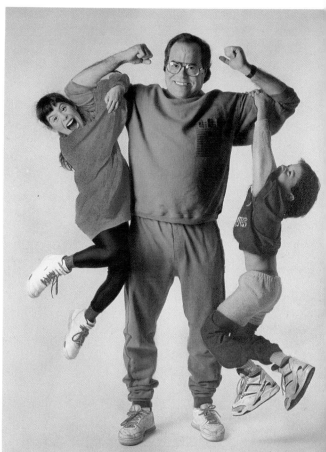

The same principle of shooting during the in-between moments applies to capturing expressions as well as actions. I ask the child about his interests or to say something silly and shoot before he has a chance to speak. His reaction to my request is what I'm after. He doesn't have to say the phrase at all.

DON'T BE A
STATUEMAKER When I was a child, the neighborhood "gang" used to play a game called statue-maker. The kid designated as the statuemaker would grab the other kids by the arm one by one and spin them around until they were dizzy, then let go and shout, "Freeze!" The rest of the kids were obligated to freeze in whatever pose they were in when the leader shouted.

As a photographer, I try not to be a statuemaker. But there are times, for instance, if you're shooting a long exposure or with the child in very precise position, when you will have to ask your subjects to be very still.

If it's completely unavoidable, make a game out of it, and even the youngest kids can hold a pose, and, I'm pleased and surprised to say, even look natural doing it.

SETTING UP
YOUR SHOT **Work fast.** Introduce the child to the setup at the very last possible moment and work as quickly as you can, without producing an atmosphere of urgency. If necessary, use a doll or other form approximately the same size and height as the child to set up the shot.

Quit while you're ahead. Most of the time my motto is "Film is cheap!" I shoot

(Left) These photos both have multiple subjects. Though they are positioned in a pleasing composition, they are not "posed" or still, but moving and natural.

Strobes; studio; Nikon 8008; Nikkor 35–105mm zoom AF lens; Kodak Plus-X 100 (professional film); printed on Agfa Portriga 118 matte paper and hand-colored with Marshall photo oils and pencils, and artist's oils.

(Right) Portraits with multiple subjects should portray not just each individual, but also the relationship between the subjects, as this playful shot of two sisters does.

Strobes; studio; Nikon 8008; Nikkor 35–105mm zoom AF lens; Kodak Plus-X 100 (professional film); printed on Agfa Portriga 118 matte paper and hand-colored with Marshall photo oils and pencils, and artist's oils.

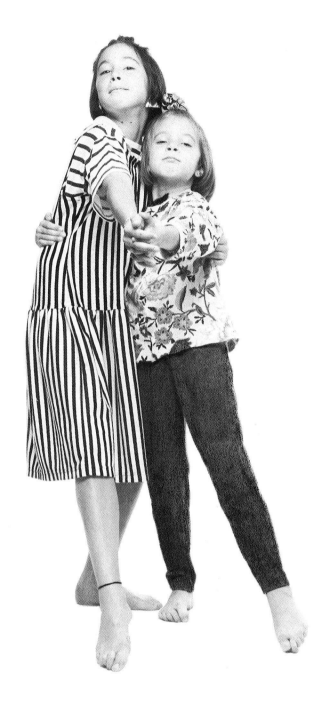

as much as I can until I think I've captured what I need, and then some. But if a static or controlled pose is needed, I find overwhelmingly that the first few shots of the take are by far the best, and the rest are often worthless. Don't belabor it and run the risk of trying the child's patience. Get what you need and stop. The first time I did this, I felt very insecure walking away from a photo session with only three shots. But with repeated success, I've learned to trust myself.

Use an assistant. If you're a professional photographer, enlist the help of the parent, or if you are the parent/photographer, enlist somebody to act as an assistant and sit as close to the child as possible (in the case of head shots, the helper can even be touching the child) and chat, play pat-a-cake, prompt and generally amuse the child so that her attention doesn't wander and she doesn't feel isolated.

(Above) Photographing kids of different ages has its special joys and challenges. Toddlers, for instance, toddle, so it's easier and more natural to shoot as they walk around rather than making them sit in one place.

Strobes; studio; Nikon 8008; Nikkor 35–105mm zoom AF lens; Fuji Velvia 50.

Plan a position that is as uncontrived and undemanding as possible. Have the subject sit down, stand or kneel. Anything that requires stamina, such as holding the arms up, is tough even for an adult to do for extended periods of time.

Do as I do. Demonstrate the position and expression you'd like to capture. Children are excellent mimics and eager to please. If you show them what you want, in addition to telling them, you'll be more likely to get it. Remember—a picture is worth a thousand words.

Avoid mug shots. Depending on what your goal is, you probably don't need to make pictures that are purely documental—what I call a mug shot. We've all seen them: child still, looking square into the camera, smiling, showing ears, eyes, teeth,

Strobes; studio; Nikon 8008; Nikkor 35–105mm zoom AF lens;
Fuji Velvia 50.

tonsils and adenoids. A good portrait or portrait series can show little or none of the face, it can be a profile, it can even be a back view. One of my first forays into portraiture was at the age of fourteen. My sister was ten and very fond of a huge, wide-brimmed straw hat. The sight of her wearing the hat and walking away from me inspired me to pick up my Polaroid instant camera and shoot. The resulting photo is still a family favorite, even though it has long since faded.

At times you may be called on to make a purely documental picture of a kid: model's head shots, ID pictures, graduation and other school pictures—all require the subject to be represented more or less full-faced, and there is little room for expression either on the art of the subject or the photographer. But if you don't have to make mug shots, don't! If you have the drive to document and simply can't help yourself, try making a couple of mug shots at the beginning of each roll of film and forget it.

Shun perfection. One professional photographer who has spent his entire photographic career making wall-sized formal portraits always strove for "that one perfect pose"—shooting subject after subject frozen in classic poses with only the slightest variations. After reading an article about my studio, his comment was, "I can't wait to let them move!"

Posing children with the heads tipped or bowed over books, hands folded in their laps, ankles crossed, or in a number of other poses considered classic or traditional may make a pretty (though predictable) composition, but they show nothing of the child's individual personality, nor do they portray the experience of childhood.

Strive for perfection and you'll miss capturing the exuberance, wonder, grace and explosive movements and expressions of childhood.

NON-TRADITIONAL AND CONTEMPORARY POSES

Beyond traditional poses, there is a whole realm of experience largely untapped by most portrait photographers. It is harder to categorize these, because they are not poses per se. So, I've divided them under different headings so that we can begin to explore them. Nontraditional and contemporary poses can be used successfully within all photographic genres, including portraiture.

Action poses include dancing, sports movements, leaping, twirling, playing air guitar, etc.

Natural poses are usually what we think of as candids: the child engrossed in play, lost in thought, examining a new object, hugging a familiar one or simply talking and gesturing normally. Natural poses can be achieved at home, on location or in the studio.

Retro poses mimic or partially re-create older styles of photographic poses of

**Don't strive for one "perfect" pose, or your work will lack
spontaneity and vitality. Forget about that "wall-sized"
portrait and just try to capture the natural child.**

Strobes; studio; Nikon 8008; Nikkor 35–105mm zoom AF lens;
Fuji Velvia 50.

children that tended to either idealize children or make them appear to be tiny adults. The limitations of photographic technology frequently required the child to sit still for long exposures, sometimes held in place by hidden braces. For this reason I don't consider these true portraits. But poses reminiscent of these older styles can be charming and interesting or even humorous, if executed tongue in cheek.

Stylized and editorial poses are used often by adult models in print, on the live runway and more recently in the American dance form called "voguing." Kids often find this type of posing amusing and enjoy it as a game of pretend, allowing for some natural expressions springing from this very unnatural style of movement.

WORKING WITH MULTIPLE SUBJECTS

Shooting multiple subjects is the most difficult to reconcile in terms of allowing the kids the freedom to move around, but still getting a shot that's also a good composition. I find it necessary to compromise by positioning my subjects. But once they are positioned, I still encourage them to interact, gesture and express themselves freely. I don't always get everyone looking in the same direction or everyone's full face in each shot, but the result is a picture that is better than a formally posed, static one.

When I shoot two siblings together, I believe there are not just two subjects in the picture, but three: the two children and their relationship to one another. By formally posing the kids, you destroy any possibility of capturing that relationship. But if you position them leaving open all the possibilities for interaction and expression and movement, you can preserve amazing moments.

Take the picture of four siblings on page 130. The children are positioned—I asked the oldest boy to sit in the chair holding his baby sister and the two middle children to stand on either side of the chair. That was all the instruction I gave them. The little girl naturally leaned in affectionately toward her nearest brother, the middle boy held the chair and regarded the camera nonchalantly and the big brother comforted the baby, who was about to squirm off his lap. The mom of this quartet loves this shot, saying, "That's them, that's exactly how they are together. I've seen this scene in my living room a hundred times. I love it that you can tell that the baby is howling in tears in the next frame."

Of course, if all the kids had been posed, looking slightly off camera and smiling in the traditional way of formal portraits, the entire family relationship would have been absent from the shot.

It is certainly more difficult to make a good picture of a group of kids without posing them, but when you do, you capture the magic of portraying both the indi-

vidual family and the universal experience of family.

My least favorite pose, and one, unfortunately, often used by portrait photographers, is the one in which the child is looking vaguely off to one side of the camera, because she is neither engaged in an activity nor with the camera (and hence, the viewer of the portrait). I believe the subject ideally should be either looking directly into the camera or focusing her attention on something she is doing or holding.

Even though your subject is looking into the camera, this doesn't mean her expression, gestures and movement won't be natural. In fact, if you're carrying on a dialogue with her, it's only natural for her to look at you, hence, the camera. After a short time, most kids will forget the camera is there and will talk to it as if they are

Many parents tell their kids at portrait sessions, "Stop mugging!" But mugging and trying out different expressions are a natural part of childhood.

Strobes; studio; Nikon 8008, Nikkor 35–105mm zoom AF lens; Kodak T-Max 100.

talking directly to me, without the lens in between. The camera needn't be hidden, and the child needn't seem unaware of the photographer to make a natural picture.

CAPTURING MOVEMENT

Of course, still, posed subjects are easier to photograph. (Where do you think we get the phrase "sitting duck"?) But nothing worthwhile is easy, as any parent knows. It's tougher to make pictures of leaping, running, dancing kids. But movement can be captured using *quick, random shooting*.

Sometimes, if the child is exceptionally active or if he's performing a dance or a sports movement like pitching a baseball or ice skating, you can get good results by simply shooting quickly and randomly. This technique works best if you have a motor drive and an autofocus setting on your camera, but it can be accomplished without these features. Film is cheap, especially compared to a lost moment, so sometimes it's best to shoot a lot, even knowing that most of the shots won't be "keepers." That perfect picture of a child at the moment her bat makes contact with

the ball or at the pinnacle of a graceful leap is worth the seventy-two others that don't make the cut. However, don't make a habit of this kind of shooting. In most situations it's still best to make every shot deliberate. Other, more technique-oriented methods to capture are discussed in chapter twelve.

To let kids feel relaxed and move naturally, they need the security to know that they're not all alone in front of the camera, and they need the freedom and space to move around, gesture and express themselves. By the same token, you the photographer need to be able to anticipate the child's movements and actions and limit them to a degree to maintain control of his position in relationship to the lens, the field and your light source. Fortunately, there are methods that, used correctly, can give both you and the child what each of you needs.

SECURITY AND FREEDOM

Natural boundaries can keep a child in place without limiting his movement. In the studio, our lighting setup helps create a kind of cove, which I believe makes the child feel sheltered and at ease and also keeps him naturally in the center of the drop. On location, finding areas that are partially enclosed can create a visually interesting field while giving the child a cozy niche to play in.

Anchors give subjects as much freedom of movement as possible while still controlling their position in relation to the backdrop and the light sources. My anchor is simply a smiley face drawn on a drop. When I walk kids onto the drop, I point at the anchor and say, "There's your mark. You can jump and dance and do anything you want, so long a you stay near the smiley face." Even kids who are too little to take instruction are attracted to the tiny face, and we've gotten many excellent shots of one-year-olds pointing delightedly at the mark.

On location your anchor can be something as simple as a twig or a rock or a bald patch of grass—anything that won't read on film but which the child can see easily. Even if you're just shooting candids at home in the living room, a tiny piece of tape on the floor can work wonders for keeping your active subjects where you want them without restricting their movement too much.

Supports are useful for babies through toddlers, giving them something to pull themselves up or lean on. Supports should not overpower the child in the photo, but can help keep him in one place and also have the added value of amusing him and helping him stay erect. Giant wooden toy blocks, rocking horses, child-sized chairs and oversized stuffed animals are some anchors that can help lead to natural-looking baby and toddler "poses."

(Above) We made this shot for a Christmas card whose legend read, "Hats off to the holidays!" In order to get this cute expression and pose, we played a game of cowgirls, and the little girl is really yelling, "Yee-hah!" here.

Strobes; studio; Nikon 8008; Nikkor 35–105mm zoom AF lens; Kodak VPS III (professional film).

(Right) By pretending to be a fairy, this girl created a graceful yet innocent dance, which we captured for a promotional postcard.

Strobes; studio; Nikon 8008; Nikkor 35–105mm zoom AF lens; Kodak Plus-X (professional film) printed on Agfa Portriga 118 matte paper and hand-colored with Marshall photo oils and pencils, and artist's oils; reproduced in black and white.

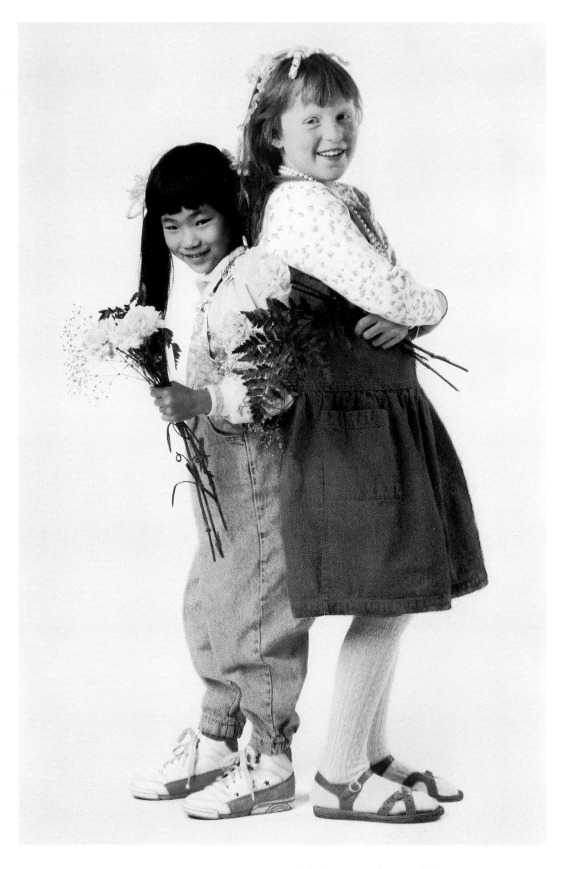

While I love action shots, a kid doesn't have to be jumping or dancing to make a great portrait. Here is a series of shots of two sisters just "hanging out" and looking natural.

Strobes; studio; Nikon 8008; Nikkor 35–105mm zoom AF lens; Kodak Plus-X (professional film); printed on Agfa Portriga 118 matte paper and hand-colored with Marshall photo oils and pencils, and artist's oils.

The child photographer must build a relationship with the parents as well as with their children, maintain a relaxed atmosphere during the shoot and encourage good rapport between family members as well.

Strobes; studio; Nikon 8008; Nikkor 35–105mm zoom AF lens; Kodak Plus-X 100 (b&w professional film).

This chapter will help professional child photographers appreciate the uniqueness of the people they really work for—the parents. And parents, this chapter will help you understand the inner workings of a photographer's mind.

KNOWLEDGE IS POWER

I always try to prepare the parents of my child clients for the shoot by giving them as much information as possible. Even if they've already seen examples of my work, I invite them to come to the studio, bring the kids and watch another family's photo session. I tell them exactly what the various costs will be so there is no room for surprise. I suggest tones and styles of clothing that work best for black-and-white and hand-colored pictures, as well as props and accessories. I give them explicit directions on how to get to the studio. When they schedule over the phone, I repeat the date and time of appointment twice. When they book in person, I write the information on the back of my business card for them. Then, I send them a letter of confirmation stating everything all over again.

In addition to all the practical information, I try to give the parents a sense of who I am and why I am a child photographer.

When I schedule an appointment, I always prepare myself by getting the names and ages of the kids and making notes about their special interests and hobbies. This serves a triple purpose: In chatting with the parents about their kids, I get to know them a little bit and learn more about what they're looking for in a portrait; it puts the parents more at ease and improves their confidence in me as a portrait photographer and in my interest in their family; and it gives me a few tidbits to talk with the kids about at the photo session.

RULES FOR PARENTS

Just as you have rules for the kids to follow at the studio (no running, etc.), so should you have rules for the parents, too. But parents are not mind readers, so you have to tell them what is expected of them.

• How much do you want them to participate? Sometimes great expressions are elicited by mom and dad. Sometimes the kids are more comfortable and cooperative if mom and dad go for a walk in the hallway. Either way, spell it out.

• Some parents want to collaborate with you on the making of their child's portrait, acting like a sort of freelance art director. Some simply want the feeling of collaborating and are satisfied to be allowed to watch the proceedings and to have you offer an occasional explanation of what you're doing. My style of portraiture leaves a lot of room for input from the parents and the kids. You may or may not want a collaborator, so make it clear from the beginning whether you welcome their artistic input.

• Just as you adhere to Vik's Ten Commandments, so should you request that the parents do. No intimidating, no saying "Smile!" and no forcing performances. The child can be asked, but he shouldn't be forced, not even by a parent.

REMEMBER THE PERSONAL TOUCHES

Dale Carnegie was absolutely right: People like and trust you more when you remember their names and use them when you talk to them. I am blessed with an uncanny ability to remember the names of my clients, their kids, their pets and their kids' dolls. I'm able to surprise and flatter people when they call me a year after their photo session and say, "You probably don't remember me, but my name is Susie Doe . . .," and I say, "Oh, Jason's mom!" If your memory isn't that good, have a file for each family and write down all pertinent names in it.

Always voice an observation or make a sincere compliment to the parent about her child. Don't say, "Your kid is the most beautiful kid I've ever seen in my life!" The compliment need not be appearance-oriented. I rarely comment on kids' appearances because I believe there already is too much emphasis on looks in our culture. Just say something that shows you're involved with, paying attention to, and seeing her child in a way that will allow you to make a successful portrait. "Gee, Donald is really into baseball," or "It's nice how Trixie and Dixie get along so well together."

PHRASE BOOK OF PARENTESE

Sometimes you can feel like you need an interpreter to figure out what parents really mean when the say certain things. After years of experience, I've come up with this handy list of phrases for conversational parentese:

• **"Do you have kids yourself?"**
 Translation: "What do you really know about kids and are you just in this for the money?"

• **"How did the pictures turn out?"**
 Translation: "Did my kids perform adequately?" (I used to suspect this one really meant, "Did you have film in the camera, did the strobes fire and did

you expose the shots correctly?" I finally learned that it really means, "Did my kids perform adequately?")

- **"I have a six-month-old."**

 Translation: "Can you retouch drool out of the pictures?"

- **"My baby just started walking."**

 Translation: "Can you take a picture of a moving target?"

- **"I have a two-year-old."**

 Translation: "Do you really think you can handle this?"

- **"I have a teenager."**

 Translation: "My child is Dr. Jekyll and Mr. Hyde. She may cooperate with you or she may not, depending on her hormonal state. Do you think you can handle this?"

- **"My daughter likes to dress up."**

 Translation: "I like my daughter to dress up."

Some parents are afraid we've never seen a baby cry, a two-year-old throw a temper tantrum, a six-year-old stick his tongue out or a teenager behave sullenly. They need reassurance that their kids' quirks are all a part of the business—a part that you love—and that their kids are not the worst kids on the face of the earth. Sometimes parents seem to have a hard time being able to tell where they end and their child begins, so they feel as though they themselves are "misbehaving" when in fact their children are simply behaving like normal children.

BEYOND PHOTOGRAPHY

It's our job to see that any tension is eased, the session goes smoothly, no one wins or loses little tiffs and you don't take sides. Practice selective blindness: you're cheerful, everything is going great, you don't notice any problems.

Treat the shoot like a big event. When you work five or more days a week in a photography studio, you can become jaded to the fun and even glamorous aspects of your business. To us it may be a job, but to parents a photo session is an event. They probably bought special outfits for the kids, got them fresh haircuts, primed them to "behave," rearranged their schedules and made a big effort to be there for their appointment and do what they could to make the shoot go well.

So you should make an effort to make the session fun, exciting and memorable. Remember that, while it can seem mundane to you, photography is still a glamorous business to most folks. That's why there's a cologne called Photo—do you think it smells like fixer? Capitalize on the glamour. Don't just give your clients a portrait; give them an experience.

A successful portrait business must continue to refine and change its product to attract new clients and keep bringing back the old ones. I took advantage of my lab's new Iris printer to create this portrait, scanned from a 35mm color negative.

Strobes; studio; Nikon N90s, Nikkor 38-135mm AF lens; Cokin star filter; Kodak VPS III print film (no longer available); printed with an Iris printer on Arches cold press paper.

So you want to own your own portrait studio? Set your own schedule? Love going to work everyday? Make money hand over fist? So did I twelve years ago. Some of these wants came true. Some didn't.

I started my "studio" in 1988, shooting in my apartment and on location, printing in my bathroom and painting prints at my dining room table. Today, I own two studios with three locations. In 1988, my gross was $7,000. In 1999, my combined gross for both studios was $1.4 million. Happily, my bathrooms and dining room are now used only for their intended purposes.

I don't, however, get to set my own hours. The highly seasonal nature of the business—70 percent of our revenue comes in the last three months of the year—and the highly personal and demanding nature of my hand-painted children's portraits demands that I have a personal hand in every aspect of production. This all requires an enormous amount of time. But on balance, would I want to trade my work for anybody else's? Not on your life, buster.

If all of this sounds good to you, then this chapter will give you the advantage of twelve years of experience, both my mistakes and my victories, distilled down into manageable form. I want to begin with three things you should do before you even begin your business: before you sign a lease, quit your day job, buy a single piece of equipment, or start eyeballing your bathrooms or dining rooms for work-space potential.

1. **Define what success means to you.**

I know what you're thinking: "But everyone knows what success is, sheesh. It's lots of money, lots of fun and lots of freedom. Right?" Not necessarily. Success is different things to different people. And when you search yourself, find your answers and commit them to paper, you may be surprised to find that your idea of success is not what you assumed it was. For example, this was my success plan twelve years ago:

- Make enough money to feel extremely financially secure.
- Create children's portraits that my clients liked and that I could be proud of.
- Love my work so much that being at the studio is as good as being on vacation.

- Have fun interacting with kids, their pets and families, and drawing out and documenting the expressions of their inner spirits.

Other photographers might add being the best in their field or winning awards and the recognition of their peers as hallmarks of their success. Some might include lecturing, making instructional videos or otherwise teaching other photographers the craft. I'm willing to bet that almost all of you will put making money at the top of your success list. We all think we want to make lots of money. But do you?

2. **Want it bad.**

I personally know three very talented photographers who are eeking out livings shooting fashion, products, food and jewelry. Their technical skills are excellent, and they have creativity to bum. So why aren't they making more money? Because it's just not that important to them.

I asked my fashion photographer friend if he'd like to, say, double his income. "Sure, of course, who wouldn't?"

"Then why don't you?" I asked.

"Oh sure, I'll just snap my fingers," he said.

"Well, you could promote yourself more. You rarely show your book unless someone asks for it, or you could get a rep."

"Oh, I just hate showing the book. And I don't want to pay a rep 15 percent on every job."

"Yes, but if a rep could do the calls for you, which you hate, and you could double the amount of work you get, wouldn't the 15 percent be worth it?"

"No, not really, because then I'd have to do 100 percent more work and only make 70 percent more money, and anyway, I like my schedule now. I only have to shoot a couple of days a week and never on weekends, and my time is very valuable to me."

So this fellow thought he wanted to make more money. But if he would have made an honest success list, making more money would not have been very close to the top. It's so important to identify what success means to you and to really want it, or you'll just think of a lot of reasons not to get it.

3. **Respect your circumstances.**

Just as everybody's circumstances are different, so should each person's entry into studio ownership be gone about differently. For instance, I have never taken out a business loan. There is a very good reason for this. When I started my first studio, I had virtually zip for money and no track record, so though I never explored the option, I'm sure no one would have loaned me a nickel.

So I started very slowly creating my business. I kept my full-time day job (for two whole years!). I invested very little in equipment: I used my husband's old college darkroom setup and my first lighting unit was a camera-mounted flash on an extension cord," which was tied to an umbrella stand with a bandanna. I spent very little on promotion, instead approaching a local toy store owner whose philosophy on kids, portraits and business agreed with mine and offered to shoot her ads for free in exchange for displaying my work in her store. It worked wonders, and for little expense. I rented a studio and equipment on an as-needed basis, so my fixed overhead was nominal. I added a second residential line in my home, thus avoiding the bigger cost of a dedicated business line. And of course I did all the work myself, from emptying the waste basket to printing, painting and designing expository material. For years I worked sixty- to seventy-hour weeks. Was this the ideal way to start my business? For me, yes. Now let me tell you about someone else who started her business in quite a different way.

Seven years ago one of my clients approached me about consulting for her to open a studio up in the San Francisco area, where her husband was being transferred. She was an attorney at the time, but she was sick of the eighty-hour work weeks, and she felt she needed a creative outlet. She said she couldn't think of anything more fun than doing what I did and thought that San Francisco was a good market for high-end, hand-created kid's portraits. Curious about whether the KidCapers concept could be "transplanted" and interested in helping her, I agreed.

Since she had already had a very successful career, her financial situation was not limiting in the way that mine was. She started out in a trendy warehouse studio with the best equipment and beautiful four-color promotional materials. She hired assistants, artists and photographic printers right off the bat. And though her start-up expenses were much larger than mine, her first year in business, as mine, showed a profit. Not many small businesses can say that! Now she also owns multiple studios, and we commiserate and trade business and technical tips.

As you can see, our start-ups were quite different, but our results similar. So pay attention to your own particular circumstances when you create your studio, and act accordingly. Begin your business in the way that will work for you, not in a way that may have worked for someone else.

Make a business plan. If you still want to own your own studio, you should make a business plan. Every year I make a new one-year plan and revise and update my five-year plan. Your start-up plan should help you do the following:

- Define your product.

- Identify what makes your product stand out in the marketplace.
- Identify the demographic to whom you will market.
- Outline your marketing plan.
- Make cash flow projections (how much revenue you will need to break even based on your fixed overhead and variable expenses).
- Identify how/where you will get your start-up money, and proposed terms.
- Determine your fee structure (how you will charge for your product).
- List your special skills that make you uniquely qualified to start this business and create this product.
- Propose a location and explain how this location will contribute to the success for your business.

Since I was not soliciting investors or attempting to get a bank loan when I started my studio, I used my business plan to help me think about the feasibility and potential pitfalls I might face. If you are looking for outside investors or loans, you will need a more thorough and formal plan. Refer to your public library for more information on this.

Your name is all-important. Twelve years ago, my blissful business ignorance allowed me to make snap decisions about issues that really should have been given more research and consideration. I didn't want to use "Vik Orenstein Photography" because I didn't think anyone would remember it, and I wanted to let people know that I was a specialist, not a wedding or product photographer who also shot kids. I used the first thing that came into my head: KidShooters. I thought the name was cute and catchy and said exactly what I did: photo shoots of kids—how witty of me!

Sadly, times have changed, and with them the connotation of the studio's name. In the winter of 1999, I decided to search for a new moniker. I asked for ideas from my clients, and the response was divided—about half said we shouldn't change our name, and half said they welcomed the change and sent along their suggestions. Some were incredibly creative, and I was moved by the strong interest from everyone, regardless of which side they took. In the end I decided to go with the name I felt most closely resembled our old one—KidCapers. It may seem a little timid to make such a slight change, but, in the words of my two-year-old daughter, it's "very scawy" to change the name of a successful thirteen-year-old business.

Time will tell whether the change helps or hurts, or has a neutral effect. But I believe it was the best thing to do.

When you choose your name, you need to take several factors into consideration.

- Your name should convey what you do. If you specialize in kids, you should have the word "kids," "children" or something similar in your name. You also need to convey the photographic part, so photo, photography, studio, shoot, shooters, snaps, clicks, portraits or pictures should be mentioned.
- Keep it short. As a general rule of thumb, most names shouldn't be more than six syllables long. If you include the word photography, you've already used four.
- Don't name your studio after yourself if your own name is very common (and therefore hard to remember) very long or hard to pronounce (and therefore hard to remember) or has a negative connotation.
- Once you've chosen your name, I recommend a copyright search. If no one else owns your name, register it. The process is a little pricey (about $400 for the search and $1,500 for the registration, minimum) but I've found that it's very worthwhile. Of course, if you're simply naming your business after yourself, you need neither to search nor register.

OK, you've got your plan, your product, your studio name and location, your first customer. Now you need to put into place some successful business practices. The following are the seven most important business practices that I have learned over the years, both from trial and error and from other photographers. I might not still be in business today if it weren't for these policies.

SUCCESSFUL BUSINESS PRACTICES

1. **Back up your product with an unconditional guarantee.**

I offer my clients an unconditional guarantee. If, at any stage in the process of creating their portraits, they are unhappy with them for any reason, I will give them a full refund in exchange for the return of all proofs and portraits, no questions asked. Sound scary? I thought so too, at first. But over the years I have had only four clients take me up on the offer. And believe it or not, this policy protects me as much as my clients, and possibly more.

The guarantee assures me that I won't have anybody out there disparaging samples of my work. And it also encourages people to shoot who I believe wouldn't be willing to take the risk if they didn't they thought they would be stuck with a poor result. I don't blame people for hesitating; portraits are one of the few major purchases we make without getting to see the final product before it's delivered.

2. **No discounts.**

While I do offer a full money-back guarantee, I do not offer to reduce prices on portraits with which clients are dissatisfied. I don't offer discounts for two rea-

sons: First, I don't want my clients to go home with a product they are even partially dissatisfied with. If I receive a complaint, I prefer to redo the portrait so it pleases the client or to invoke the refund. Second, this protects me from the occasional client who is in the habit of complaining in order to collect a discount, whether or not there is anything to complain about.

3. **Offer incentive prices.**

I list my portraits in my price list at my regular rate. At the bottom of the list, there is a banner that says, "Ask about our incentive prices." The incentive prices are 15 percent off the regular price, and clients receive these lower prices if they select their portraits at the design consultation, the meeting where they see proofs for the first time. I offer incentive prices for a number of reasons, not the least of which is to keep my production on schedule. During my first years I had no such fee structure, and all my clients would take their proofs home with them to mull them over and then forget about them until about three minutes before Christmas, when they would call and ask me to rush their order for them. Another reason is clients' satisfaction. Inevitably they are happier with their portraits when they go with their gut reactions and take advantage of the expertise of our photographic designers. Many photographers use incentive pricing because they believe it results in higher sales because the parents are more excited the first time they view their children's proofs. In my experience, though, incentive prices don't affect the size of the purchase.

4. **Charge a cancellation/rescheduling fee.**

When my KidCapers clients schedule their shoots, we require the sitting fee in advance to guarantee their appointment, and if they reschedule or cancel, $15 of the sitting fee is nonrefundable. We don't do this just to be mean. We instituted this policy at a time when our reschedule and no-show rate was 50 percent. When you're dealing with a deadline, such as Christmas, Easter or a birthday, this is shooting time that cannot be replaced. We considered double booking, as is a common practice with other studios, but we knew we wouldn't get nearly the results we get when we never keep a child waiting. Now with our $15 reschedule fee, our cancels and no-shows are down virtually to zero. Why this works, I have no idea. Obviously $15 isn't going to make or break either my clients' budgets or mine. But I won't argue with success.

5. **Make studio visits mandatory.**

In order for our clients to receive our 100 percent guarantee, we require that they visit the studio before their sitting date to meet us, see our framed samples,

get ideas for wardrobe and props, familiarize themselves with the shooting bay and ensure that they know their way here so they don't get lost or stressed out on the day of their shoot. We do make exceptions if the client lives out of town, but about 99 percent of our clients make a studio visit and are glad they did. Even the ones who complain understand once they're here the benefits of the extra time, planning and creative input it affords them.

6. **Turn away business.**

No, I'm not kidding. Specializing means turning away business. When I first started KidCapers Studio, general wisdom held that a photographer in a medium-sized market such as Minneapolis needed to be a generalist. But I didn't feel I could do everything and do it well, and I really didn't want to. So when the inevitable calls came in asking me to shoot weddings, events, products and the kitchen sink, I gritted my teeth and said no. It wasn't easy, but I remembered something an architect once told me: "I never hire shooters who come in here showing me a few pictures of buildings sprinkled in with their pictures of candy and girls. I only hire shooters who only shoot architecture." And then a funny thing happened. I started getting calls from national commercial clients such as Nikon, Pentax, Microsoft and others asking me to shoot commercial jobs that featured kids. I sincerely believe I wouldn't have gotten these jobs or grown my photography business as much if I hadn't turned away those weddings.

7. **Give good customer service.**

Always try to look at things from your clients' point of view. In the "old days," I used to become annoyed when clients wanted coloring changes or reshoots, and although I would generally accommodate them, I'm sure my attitude wasn't as bright as it could have been. Then one day I ordered carpeting. I picked it out at the store under fluorescent lighting and went home happy, thinking I had purchased a more or less beige carpet. Three weeks later, when the installers came and pulled a huge roll of stark, glaring white carpet off their truck, I ran into the street screaming, "That's not what I ordered! I would never order a white carpet with three cats and two dogs in the house!" I behaved like the customer from hell. I called the store and found out that the carpet delivered was indeed the color I had ordered. It just looked whiter in the bright summer sunlight than it did in the store. So now when a client says, "I meant green like in nature! This isn't green like in nature!" I take a breath and remember standing in the street screaming at the carpet guys, and I say, "Oh, it'll be no problem to change that." And I really mean it.